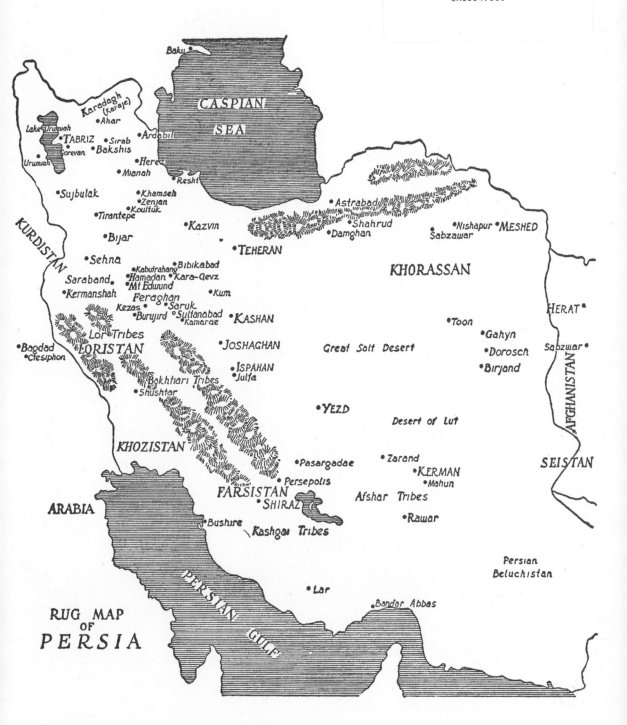

RUG MAP
OF
PERSIA

ORIENTAL
RUG
SYMBOLS

ORIENTAL
RUG
SYMBOLS

Their Origins
and Meanings
from the
Middle East
to China

JOHN TRAIN

PHILIP WILSON

I am very grateful indeed to Maria Teresa Train for
pursuing this project, to Rosalind Benedict for expert
counsel, to Sara Perkins for editorial assistance, to
Ruth Ann Waite for patient transcription, and to
both the carpet department at Sotheby's, London,
and Sally Sherrill for careful review. Eileen Badoukian
Hampshire and Samir Mazri kindly read the text.
Cavit Avcü arranged a special viewing at the Türk
Ve Islam Eserleri Müzesi, Istanbul.

It would be a pleasure to hear from scholars with
further interpretations of these or other symbols.
British readers are invited to write care of the
publishers, and American readers to 135 Mianus
River Road, Bedford, NY 10506.

© John Train 1997
First published in 1997 by
Philip Wilson Publishers Limited
143–149 Great Portland Street, London W1N 5FB

Distributed in the USA and Canada by
Antique Collectors' Club Ltd, Market Street Industrial Park
Wappingers' Falls, NY 12590, USA

ISBN 0 85667 464 8
Library of Congress No. 97-061681

Drawings by Irina Ourusoff
Designed by Natasha Tibbott
Printed and bound in Italy by
Società Editoriale Libraria per azioni, Trieste

Contents

✦

Introduction

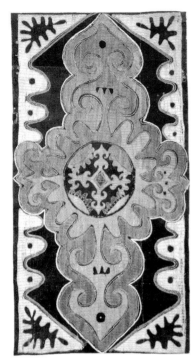

Cloud collar. Kaitag, Daghestan, Caucasus, 18th century.

Among the domestic objects that surround us, carpets are often the least carefully observed. One notes the overall effect but not the details. Still less do we take account of their symbols. And yet they may contain dormant messages of great importance and interest.

In an article on the iconography of a Florentine altarpiece, Herbert Freidmann speaks of the symbolism of the animals, birds, reptiles, flowers, plants and other themes in such painting: '... These creatures', he observes, 'were not merely idle whims of the artists; they had significance, they conveyed meanings to the people of fifteenth-century Italy, and their inclusion was probably passed on and approved, if not actually requested, either by those who commissioned the paintings, or by the clergy or by both. A very large part of the audience for which these works were intended was illiterate; people were accustomed to "read" pictures and probably looked more intently at all parts of the painting than we are apt to do today. We may see only decoration in paintings that were once understood as richly symbolic.' Much the same is true of oriental carpets. They contain few designs that are just designs; instead, they are trying to speak to us. Some symbols are talismans against the hazards of everyday existence, while others invoke religious or mythological themes or immemorial archetypes.

The analysis of symbolism encompasses anthropology, religion, ethnology, linguistics, sociology and other disciplines. This book only focuses narrowly and selectively on certain aspects of these areas of study but aims, instead, both to increase readers' enjoyment of carpets by heightening their

awareness that the symbols exist and to provide some possible interpretations, rather than attempting a full scholarly discussion. Identifying some of the symbols and motifs, for instance, the way one identifies a bird or flower, helps one grasp what is being seen, irrespective of any concern about interpretation. In a few instances I have sought to cast some light on a symbol by referring to a usual significance in mythology, even where scholarship may not link it solidly to that meaning in a tribal context.

Of the Chinese and Middle Eastern carpet symbols in this compendium, the Chinese are easier to read, because the code is generally clear and specific. Middle Eastern carpets, on the other hand, are shifting and complicated, but sometimes richer.

History

Carpet[1] weaving is an ancient craft. The oldest surviving carpet dates from about the fifth century BC: two and a half millennia ago. Found in the Pazyryk tomb in the foothills of the Altai mountains in Central Asia, it is elegantly executed, and clearly reflects an already well-developed tradition. It depicts animals, rosettes and other motifs[2] that are still in use today. One can readily suppose that the origin of the craft of making carpets dates from a great deal earlier. The Book of Exodus describes their manufacture (one is shown on an Assyrian relief of the ninth century BC) and they existed in ancient Egypt. (Later, Cleopatra was physically carried to Antony rolled in a carpet.)

A few of the main symbols found in carpets from the Middle East to Asia go back to earliest times. Examples discussed in the text include the *Tree of Life*, the *Swastika*, the *Eagle*, the Paisley design or *Boteh*, and the *Palmette*.[3] From pre-history to the rug under your feet, a number of these motifs have a degree of continuity. Some were introduced by waves of Central Asian and Mongol invaders, or borne on the Silk Route. Several

[1] I use 'carpet' and 'rug' interchangeably, with two exceptions: mosque or palace *carpets*; nomad *rugs*. Today, one also speaks of scatter *rugs* and wall-to-wall *carpet*. In English usage, carpets are rugs above a certain size, nine by seven feet, say.

[2] By 'motif' I mean a design that may not have further symbolic significance.

[3] Capitalized terms are illustrated.

characteristic features of Islamic art came from the Seljuks, who descended upon the Middle East from central Asia early in the eleventh century, long before the Mongols in the thirteenth century. And as described on pages 42–44, there were tribal movements and religious and cultural changes over succeeding centuries.

Important carpets, including court and mosque pieces, were woven in workshops, where their designs and symbols were often much more elaborate than those found in tribal carpets; they are full of religious and other references, many of which are discussed in the text. The amount of hand work in such carpets can be prodigious. Two to four hundred thousand knots per square metre is usual, and a few Nain or Isfahan pieces have one million.

Stylization

The Islamic avoidance of direct representation of natural objects (which was not universal) tended to reduce some carpet forms almost to diagrams. In addition, the elements in Middle Eastern rug design that were borne from Turkestan or China were often garbled in the course of their travels, and thus slid the more easily into conventionalized designs. A Turkish villager's notion of a dragon, for example, offers considerable latitude, to say the least. As described later, animals, birds or flowers often merge into composite forms, while certain of them, such as the dragon and the sunbird, may metamorphose into flowers as their earlier significance fades.

It was Islamic tradition, the *Hadith*, not the Koran itself, which only forbids idolatry, that discouraged the depiction of natural things. (The same prohibition — universally neglected — exists for Christians in the Second Commandment.) Why, then, do some carpets observe this injunction and some not? There is a division between sophisticates and simple folk. While some patrons of court weavers might ignore the prohibition against depicting objects, it was more carefully followed by the mullahs and their faithful; if for some reason such things were to be rendered, they were abstracted into symbolism. This distinction, based on the position in society of the weaver's patrons, is probably more valid than the familiarly cited one

between the orthodox Sunni and less fundamentalist Shiites. The sixteenth-century Safavid dynasty in Persia leaned to Sufism, and allowed pictorial representation of Sufi conceptions in textiles. Alas, these glorious productions are encountered chiefly in museums.

Origins

Symbols tend to evolve. For instance, in seventeenth-century Persia, when, after a period of openness, figurative themes were suppressed, dragons and sunbirds dissolved into floral motifs. Some motifs are also difficult for an unskilled weaver to render, and so become schematized. Thus there are often many layers of possible interpretations of rug symbols, particularly Middle Eastern. Recent scholarship is trying to peel back some of these layers, rather like disinterring a buried city.

This study resembles etymology. As we trace our words back, we find that time has introduced many unexpected alterations. A word's meaning will be different between one place and another, and one time and another. Indeed, some words end up meaning the opposite of their earlier significance.[4]

So too with the symbols in carpets. There exist long studies on many of them. They often develop into composite types, or partially merge with quite different designs. For instance, a lamp hanging in a *mihrab* may turn into a bunch of flowers. The reader should, therefore, consider many of the interpretations that follow, particularly of Middle Eastern symbols, as indications, or even possibilities, rather than facts.

Carpet owners and dealers who are unfamiliar with the iconographical aspects of the subject often provide garbled explanations for the motifs. The characteristic device or *Gül* of Turkoman tribes is not infrequently called an 'elephant's foot', a complete invention. 'Wineglass' and 'crab' borders do not represent wine glasses or crabs; they just happen to look like them to us.[5] Even in the rug-producing areas the weavers or

[4] E.g., to 'cleave', which means both to split and to stick together. (See the author's booklet on *Antilogies*, London, 1988, summarized in *Crazy Quilt*, New York, 1996, HarperCollins).

[5] Under the illustrations, incorrect or questionable terms in common use are placed in quotation marks, thus: 'wineglass' border.

merchants are likely to account for symbols by telling the buyer what they think he wants to hear. Thus, a Turkoman carpet may be called a 'princess Bokhara',[6] instead of being identified by the tribe that made it, as though one spoke of a 'princess Paris' wine. Similarly, 'Samarkand' rugs were traded in Samarkand rather than woven there.

The Philosophical Context of Middle Eastern Carpets

A Persian rug may bring both the natural world and a semblance of earthly paradise into one's dwelling. To no small degree, the natural world was for a philosophical Persian, as for a medieval European, a filtered reflection of the divine order. Thus, such a rug can sometimes be understood at several levels: first, a religious or philosophical abstraction symbolized by a natural object, and then this natural object reduced to a stylized abstraction. So to grasp the full richness of the symbols of some oriental carpets, one should try to situate them in their general cultural and religious context.[7] Take a medallion carpet (see pages 18–19, 21, 29 and 30). Typically, it has a diamond or lozenge in its centre, and triangles in each corner of the field. This overall design apparently illustrates what is sometimes called the old Asian cosmology, known, among other sources, from ancient Chinese mirrors. Gazing at the heavens, the Asians speculated on the nature of the sky. It was clearly an inverted bowl, but what held it up?

One answer was, in essence, an immense tent pole, sometimes called the *Tree of Life*. So if the whole field of a medallion carpet represents the sky, then the socket for the tent pole is in the centre, called the sky gate, of the central lozenge, perhaps enclosed by a *Cloud Collar*. (The dwellers in a tent

[6] Bokhara at least exists, although rugs are not made in the city; there are no such places as Karastan, Kabistan, Gulistan or Sharistan; nor, for that matter, Dinar, Elvand, Lavher, Luleh or Zarif.

[7] This is exceedingly difficult in folklore studies unless you have actually sat around the campfire ... and even then! Different cultures *see* images differently. Scholar Lin Yu Tang complains in *My Country and My People* about how foreign languages were once taught in Chinese schools. Word-by-word translations were attempted without understanding the framework. One of his students rendered *Notre Dame de Paris* as 'Our French Wife'!

might place a cloud collar to enclose the smoke hole in its top.) Through the sky gate one can hope to glimpse the Garden of Eden! But how does the sun enter the bowl? In medallion carpets the answer is represented by the diamonds in the corners. At one solstice, the sun enters through the diamond aperture in one corner, and exits through the opposite one; at the next solstice, it enters and leaves through the other two diamonds.

This old Asian cosmology, carried by invaders and traders from Mongolia and the Asian steppes, influenced the Middle Eastern world-view. And, of course, seeing the sky as a vast bowl is a natural interpretation, common to many cultures. The ancients knew well that the firmament pivots about the pole star; so they situated the sky gate at the point where the heavens rest on the celestial axis, both physical (the *Tree of Life* or world tree or column) and spiritual.[8]

The inscription of Maqsud of Kashan on the prodigious Ardebil medallion mosque carpet, now in the Victoria and Albert Museum in London[9] reads, approximately:

> I have no refuge in the world beside this courtyard;
> My head has no pillow but this gateway.
> The work of a slave of the courtyard....

Beside the actual portal of the mosque, Maqsud was probably referring both to the court of the Shah[10] and the sky gate. The lines are adapted from the poet Hafiz, writing some two centuries earlier, who often writes of the dome of the sky. One thinks also of Edward Fitzgerald's rendition of Omar Khayyam: 'In this inverted dome we call the sky / Whose portals are the alternate night and day', and indeed the first

[8] The story of Father Christmas, bringing good things down the chimney, which thus links a higher world with our own, may be a form of this archetypal theme. The legend of St. Nicholas, Bishop of Myra and patron of mariners and pawnbrokers, includes an impoverished nobleman who despaired of providing adequate dowries for his three daughters. They seemed destined for a squalid fate. Then, on successive nights the saint tossed rich purses in their windows, and honour was saved.

[9] It contains about thirty million knots. A reduced companion piece is in the Los Angeles County Museum.

[10] Presumably Tahmasp, 1524–1576, the second Safavid, in whose reign were woven the greatest Persian carpets.

words of that version: 'Awake! For morning in the bowl of night / Has flung the stone that put the stars to flight...' So, if we cannot live under a dome representing the sky, like the Pantheon in Rome, and with an oculus in the top looking toward heaven, we can still enjoy a visual reminder of that idea under our feet.

Mysticism

Perhaps I can hint at the richness of some symbols by citing the *Simurgh*, the king of birds: also, for the Sufi mystics, the divine reality. Farid ud-Din Attar's prodigious *Mantiq ut-Tair* (The Conference of the Birds) is a metaphor of man's spiritual progress. A flock of birds wander the earth seeking their leader, the *Simurgh*. Finally they reach his house, where they learn that they—30 birds (*si murgh*)—are also themselves the *Simurgh*.

Incidentally, just as in English one talks about 'weaving a spell', in Persian one 'weaves' (*baftan*) poetry. Equally, carpet (*farsh*) in mystical poetry can become the 'path' (*farsh*) to enlightenment.

A concept implicit in the field pattern of many Islamic carpets is indeterminacy. The field often seems not to be the right length: major pattern elements are cut off by the border in a fashion we find disconcerting. Sometimes this is because a village rug is not woven from a cartoon: the weaver stopped when the rug had become big enough. Often, however, the field of an Islamic carpet is intended to be a snapshot of the universe, of which one section is as valid as another, like the clouds drifting across a landscape. The fields of many carpets are intended as a glimpse of eternity, without a precise beginning or end, and conceptually extending out beyond the border.

Some Persian rugs are full of nature: hunting scenes, birds, and particularly gardens; presumably water-gardens, called in Persia *chahar bagh* or 'quartered gardens'.[11] Since eastern gardens require irrigation, the lines that cross the body of a garden carpet were originally canals, often complete with fish

[11] According to one tradition, the second-oldest carpet we know of was made for a sixth-century Sassanid king, Chosroes I, and depicted a garden, with paths leading between streams; he placed it in his palace at Ctesiphon in winter to remind him of the spring.

and waterfowl, and suggesting the flowing streams of paradise described in the Koran. The two words that the Koran uses for paradise, *firdaws* and *janna*, mean 'garden'[12] . The crusaders brought back the pre-Islamic plan of a square garden divided into four sections, which later became typical of European garden plans.[13]

Persian hunting carpets contain rich symbolism. On a mundane level, hunting, like chess, is a war game, indeed a surrogate for battle, which is an aspect of kingship. On a deeper plane, the hunter merges with his prey, just as the soul merges with divine unity. In medieval England, an exceptional stag hunted by the king and released became a 'stag royal proclaimed', and could not be killed. A similar custom existed in Persia. Thus the Sufi poet Jalal ud-Din Rumi identifies the mystic, captured by God and set apart from other men, with the huntsman's quarry.

Folk art

Carpet-makers in many tribal areas often faithfully repeat designs century after century, each daughter carefully maintaining the tradition imparted by her mother. As with many folkways, and with personal names, she undoubtedly feels that the work or the ritual is imbued with a certain power, or magic, which will be diluted or lost if significantly altered. (Westerners think the same way about religious apparatus and rituals.) When a bride arrived in her new home she might bring certain traditional carpets, which she had made with particular craftsmanship, and which were then displayed around the *yurt*

[12] As Shusha Guppy says in her enchanting description of her childhood in Persia, 'In most European languages, the words "garden" and "paradise" are related to the ancient Persian word *paradaiza*, meaning "the Lord's enclosure." In Persia, where rainfall is limited to a short season and water is always scarce, making a garden traditionally meant creating a personal paradise, a reflection on earth of the Garden of Eden. It expressed the soul's aspiration to eternal peace and beauty. Persian rugs, with their stylised birds and plants, were originally a representation of Paradise, and even the Flying Carpet of fairy tales was related to the longing for return to Eden.' Shusha Guppy, *The Blindfold Horse*: see Bibliography.

[13] A four-part mandala often represents the cosmos, and is thus an aid to meditation. The central point may be the mountain — the 'peak of judgment'—that is the axis of the cosmos, and the seat of Buddhas and gods.

(see '*Khatchli*', page 91). She knew that her newborn child would be laid on its own rug, and that she herself would go to her grave wrapped in her funeral carpet. Of course these creations would be invested with a sacramental quality, and their designs not lightly tampered with. In earlier times the patient weaver in her *yurt* had a direct apprehension of life, and also a wonder at the meaning in things, which symbolism helped express. A nomad family's rug lay directly on the ground, and may have been its principal possession, on which they prayed, slept, ate and received guests. And its rich colours may have provided a restful contrast to a desolate landscape.

Our taste generally prefers clean lines, and is often puzzled by the complexity in the field patterns of most Middle Eastern carpets. (We westerners like to fill *time* with sound and cultural clutter.) This may resemble the innumerable protuberances on the roofs of Gothic cathedrals and to some extent Far Eastern temples, which do not end crisply, like modern architecture but, instead, lift off into an infinity of complex forms, resembling a leafy tree, giving the viewer the impression that the cathedral is fading into the sky — almost joining with it. Modern architecture's hard-edged shapes give the opposite effect: there is a sharp break between the sky and the here and now. So too, moderns think of themselves as outside nature and the spiritual world to which more traditional societies have felt closer.

We should note an important purpose of folk symbolism, namely that of averting misfortune, sometimes called its apotropaic function. Archaeologists of the fourth millennium rooting around in the remains of our cities may well be astonished to find that the people that sent men to the moon did not dare to put the number 13 on an elevator. We should thus not be surprised at the multitude of symbols to avert the widely feared evil eye, or the bites of scorpions, snakes or tarantulas.

Some Secondary Aspects of Carpet Motifs

A visitor to a mosque or other Muslim public place will be struck by the large ornamental Arabic characters placed in conspicuous positions. They usually contain a simple Koranic message, such as 'God is great'. Sometimes the characters are so highly elaborated as to become unreadable; in other words,

the elegance of the writing has overshadowed its literal sense. In much the same way, forms derived from Arabic script are sometimes used in the borders of oriental rugs. This type of border is usually called 'Kufic' or perhaps more properly 'Kufesque', after the Mesopotamian town of Kufa, home of the earliest written Arabic, later highly stylized. The Kufic border does not ordinarily represent specific characters.

One occasionally finds an Islamic date on a carpet. To convert it to our calendar, one cannot just add 622, the year AD (or CE) of the Hegira, Mohammed's flight from Mecca to Medina, when the Muslim calendar starts. The reason is that the Islamic year, being lunar, is eleven days shorter than our own Gregorian solar year. Instead, one can divide the year AH by 33, subtract the result from the original date, and add 622.[14] A certain hesitation is appropriate, since a date on a carpet, as on some wine labels, may be set back deliberately (see page 94).

Depending on the region, colour can be significant in Middle Eastern carpets. The universal cheerful red suggests virile fortitude and joyful youth. Green is the sacred colour of the Prophet and his banners, of the turban of a *hadji* who has made the pilgrimage to Mecca, and of paradise. It implies hope and renewal. Blue is a colour of the sky, authority, strength, age, and sometimes of royalty; in certain contexts it may avert the evil eye. It is also the colour of Sufi robes and mourning. Yellow suggests summer's ripe grain and thus abundance and youth. Orange, as the colour of some dervish robes, may imply piety and humility. As in the West, white is the colour of innocence and purity (whence 'candid', white); also death. Black, a manly colour, also shows respect for the bereaved.

Carpet motifs such as birds and animals often have reduplicated elements, such as extra heads. This may suggest added power, as in the familiar double-headed eagle, or, by increasing symmetry, may be merely ornamental.

In addition to the designs in the field of a carpet, a specialist will give close attention to the border, which can help indicate the

[14] For instance, assume that a rug is woven in 1300 AH. To start, 1300 divided by 33 gives 39. Subtracting that from 1300 leaves 1261. Adding 622 gives 1883. Or assume the date is 1318 AH. Dividing by 33 gives 40, which subtracted from 1318 leaves 1278. Adding 622 gives 1900.

place of manufacture. Borders are less rich in symbolism, however, and are thus not covered here in detail. Some important examples are grouped in a separate section for identification purposes.

Plan of the Book

Middle Eastern and Turkoman symbols are covered in Part I, subdivided by categories: Animals, Birds, Flowers, and so on.

Chinese symbols are covered in Part II. Since many readers will not at once make out those highly stylized designs, they are placed alphabetically rather than by category. So to 'read' a Chinese rug with the help of this compendium, first familiarize yourself with the designs illustrated, and then match them up with those in the rug that is being studied.

The Index covers all the symbols illustrated, of whatever origin.

My hope for this book is that readers will find their pleasure in this rich and universal form of art deepened and intensified. Perhaps in time they may come to feel, as I do, that the greatest carpets, such as the Ardebil and the Sanguszko (both illustrated), are among mankind's most wonderful artistic achievements.

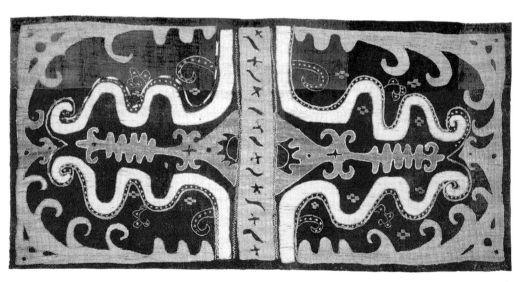

Two serpents surrounding Tree of Life. Kaitag,
Daghestan, Caucasus, 19th century.

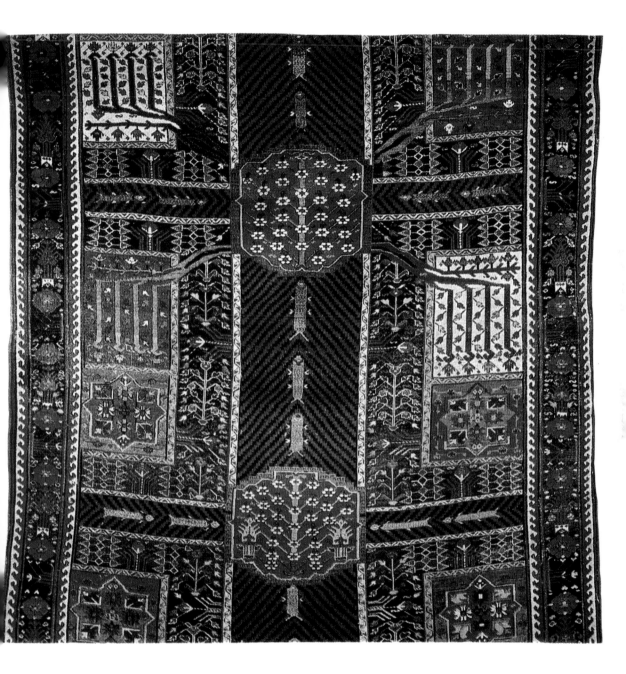

Chahar bagh garden carpet. Persia, c. 1800. Private collection.

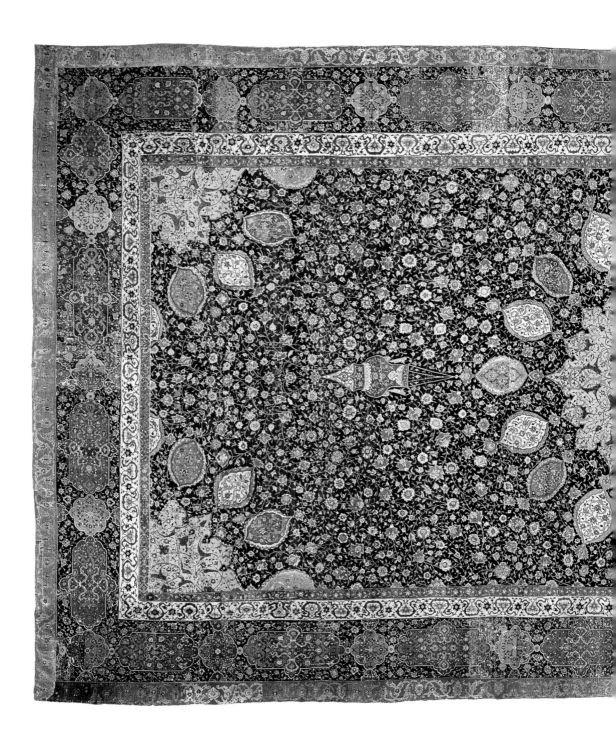

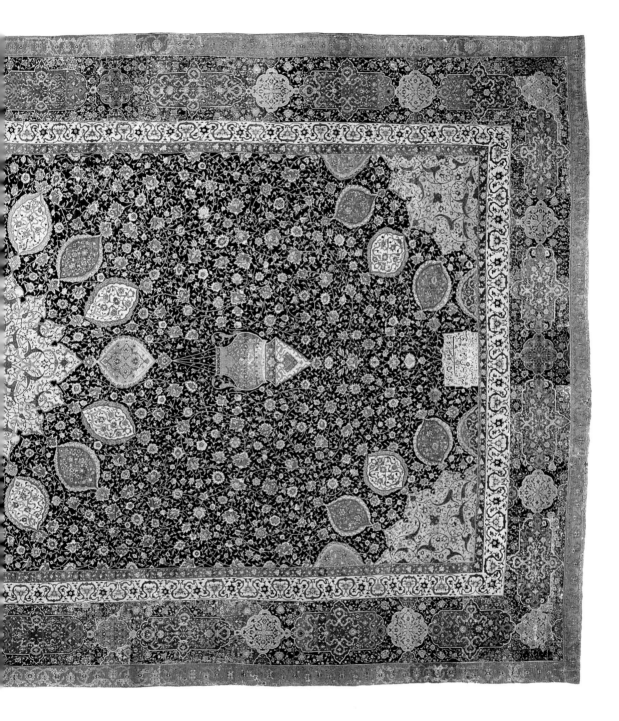

The Ardebil Carpet. Medallion carpet, with pendants representing the sun and moon. Safavid, mid-16th century. Victoria and Albert Museum, London.

Detail, Shumei Sanguszko medallion and animal carpet.

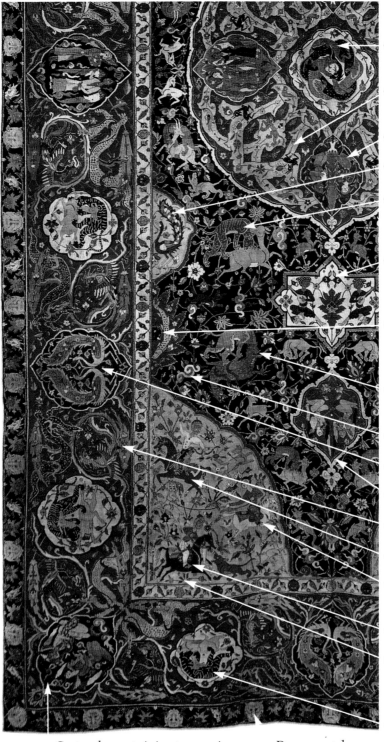

- Oculus containing fighting dragons

- Arabesque with birds and antelopes

- Medallion

- Bird of paradise

- Lion (suggesting the Shah) fighting onager

- Pendant containing musicians, symbolizing paradise

- Fish, suggesting waters beneath the earth

- Two celestial animals fighting

- Cloud-band

- Birds of paradise

- Pendant with angels

- Dragon and phoenix

- Mounted archer

- Horseman lassoing antelope

- Shah killing lion

- Corner medallion showing hunting in paradise

- Black underworld tiger fighting onager

- Cartouche containing two peris: one, saved, with bird of paradise; the other, damned, with onager, a rebus for "unbeliever."

- Demon masks

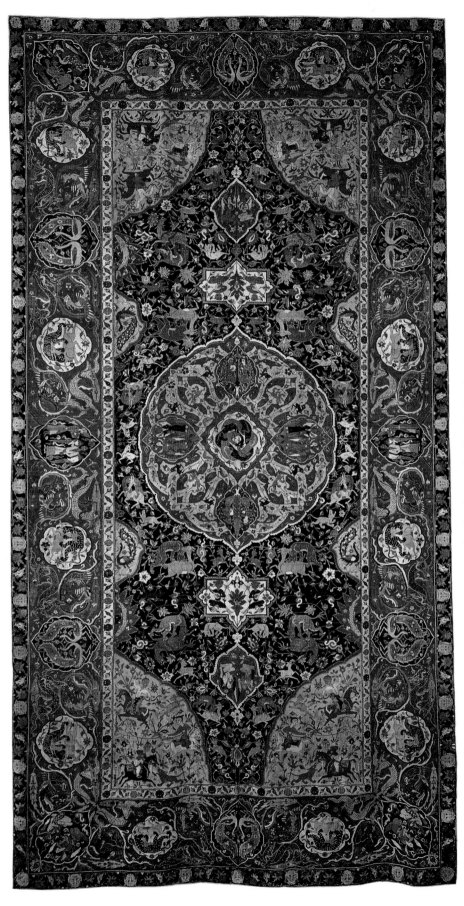

Shumei Sanguszko medallion and animal carpet. Kirman, late 16th century. Miho Museum, Shigaraki, Shiga, Japan.

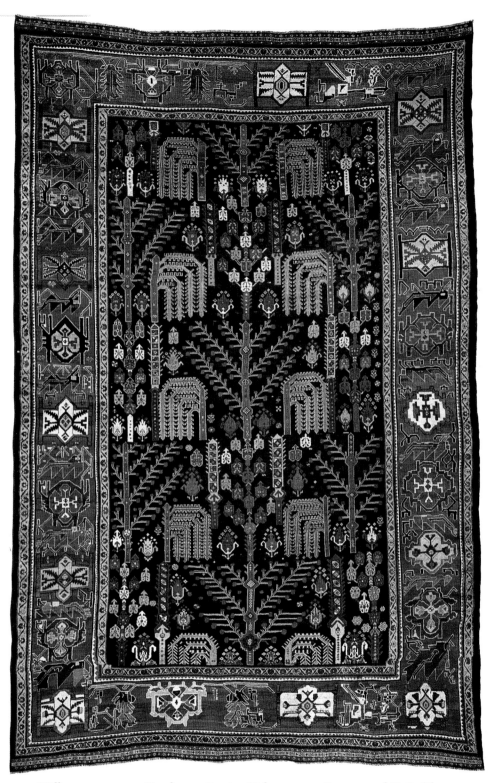

Willow tree carpet. Northwest Persia, 19th century. Courtesy of D. L. Blau.

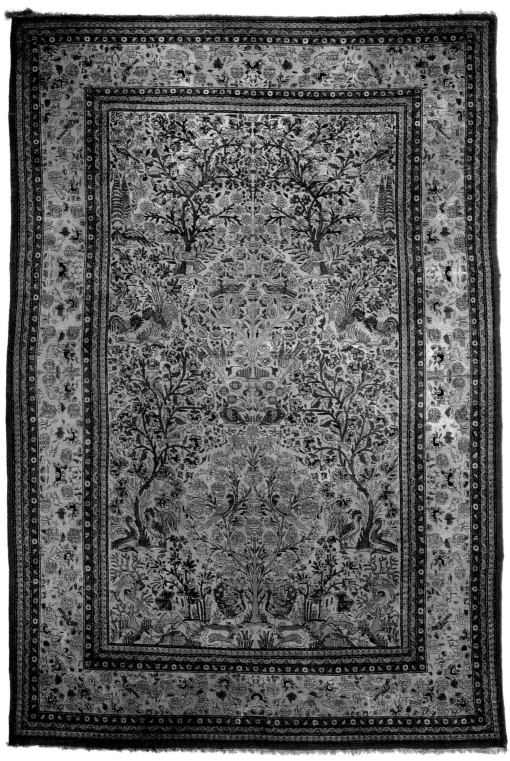

Garden carpet with tree of life, animals and birds. Kashan, 19th century.
Courtesy of D. L. Blau.

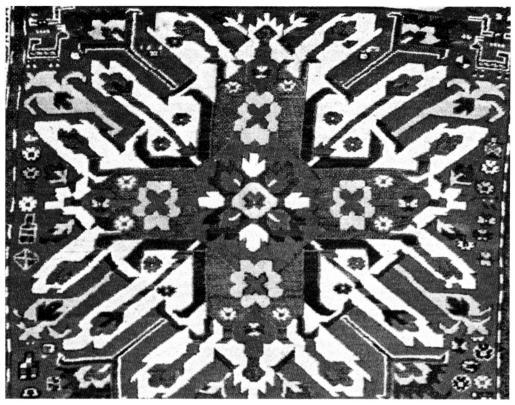

'Sunburst' or 'eagle' Kazak, also known as Chelaberd.
Karabagh, south Caucasus, 19th century. Private collection.

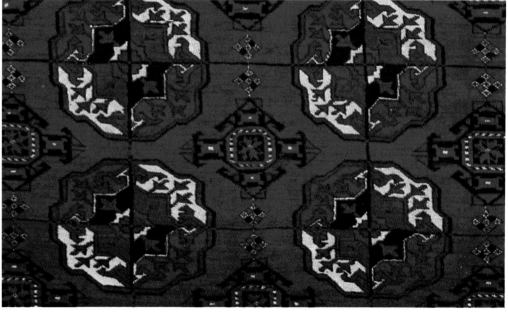

Tekke güls. Turkoman, 19th century. Courtesy of D. L. Blau.

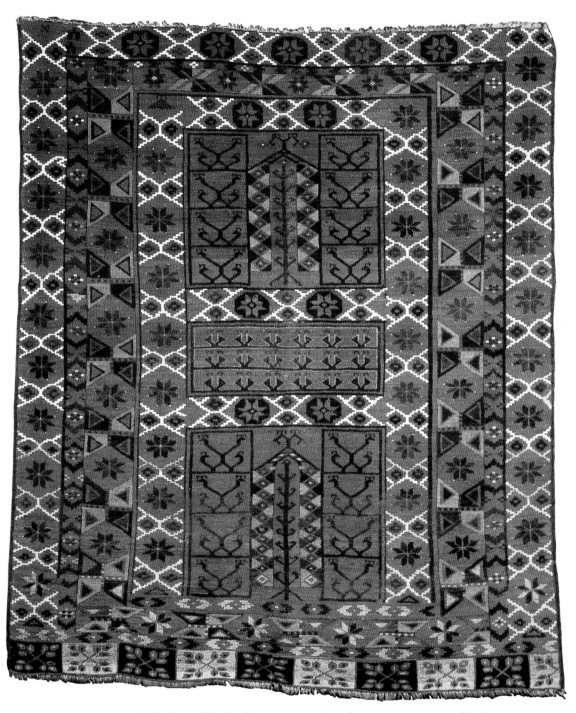

Ensi, also called 'Khatchli'. Turkoman, Ersari, 19th century. Private collection.

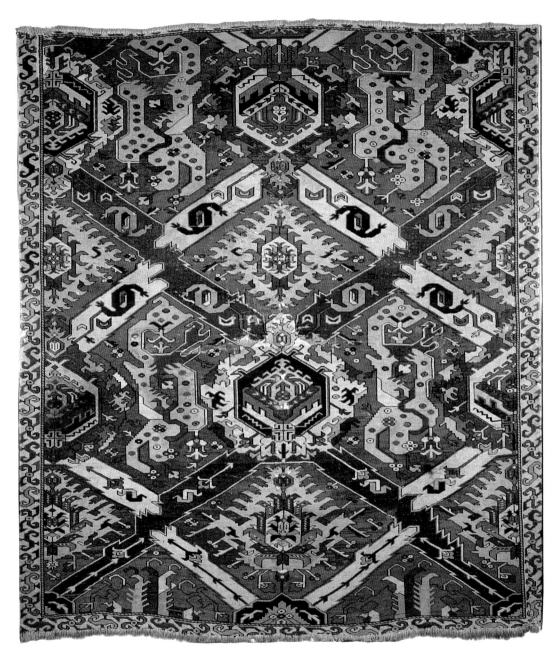

Caucasian dragon carpet. Asia Minor, 16th–17th century.
Victoria and Albert Museum, London.

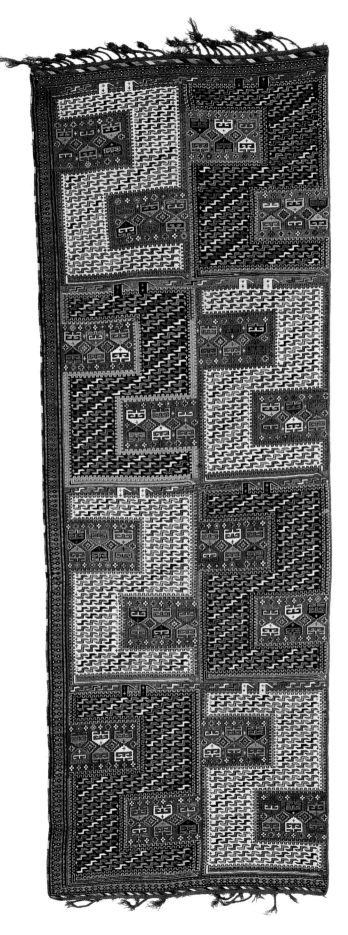

Dragon Sileh carpet.
Caucasus, 19th century.
Courtesy of D. L. Blau.

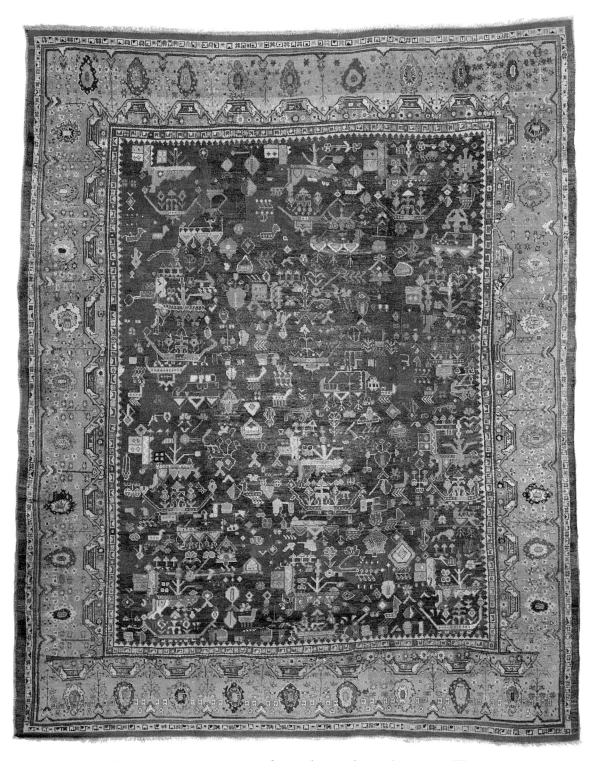

Decorative carpet. Many amulets and animals as adventitious fillers.
Turkey, 19th century. Courtesy of D. L. Blau.

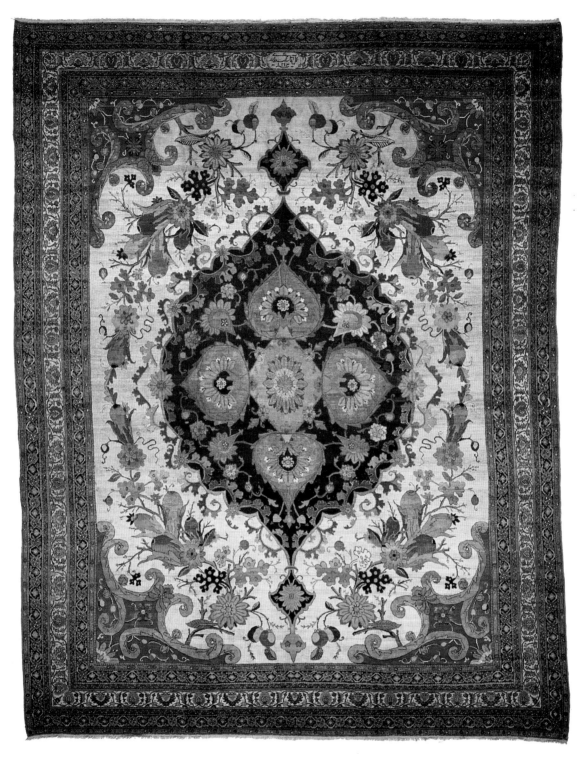

Medallion carpet. Tabriz, 19th century. Courtesy of D. L. Blau.

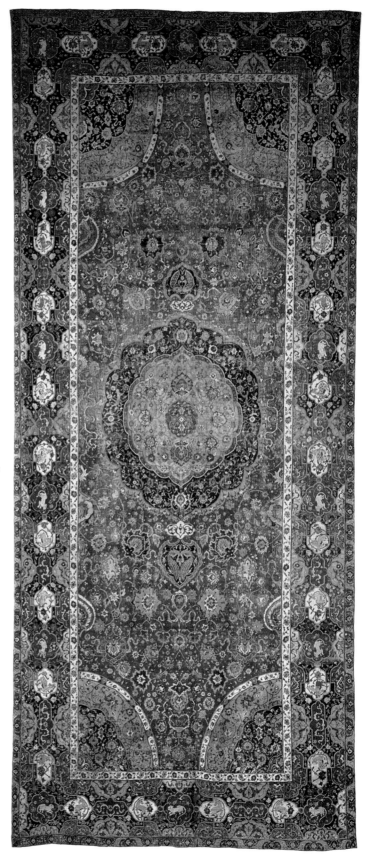

*The Seley Carpet.
Masks, stylized animals,
cloud bands. Herat, Safavid
Period, 16th century.
Metropolitan Museum
of Art, New York; presented
in memory of Richard
Ettinghausen, Gift of
Louis E., Theresa S., Hervey
and Elliot J. Seley and
purchase, Harris Brisbane
Dick and Fletcher Funds.*

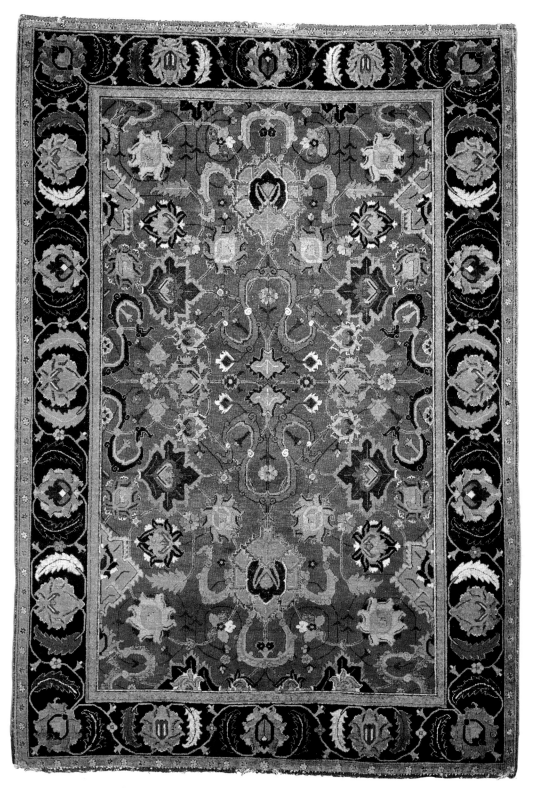

Mughal Isfahan design carpet. Cloud bands, palmettes with serrated leaves.
India, 17th century. Museum of Fine Arts, Boston; gift of John Goelet.

*Details of the Pazyryk carpet. Scythian burial mound,
Altai mountains, 4th century B.C. 1) Horse and groom;
2) Spotted stags, with griffins in medallions.*

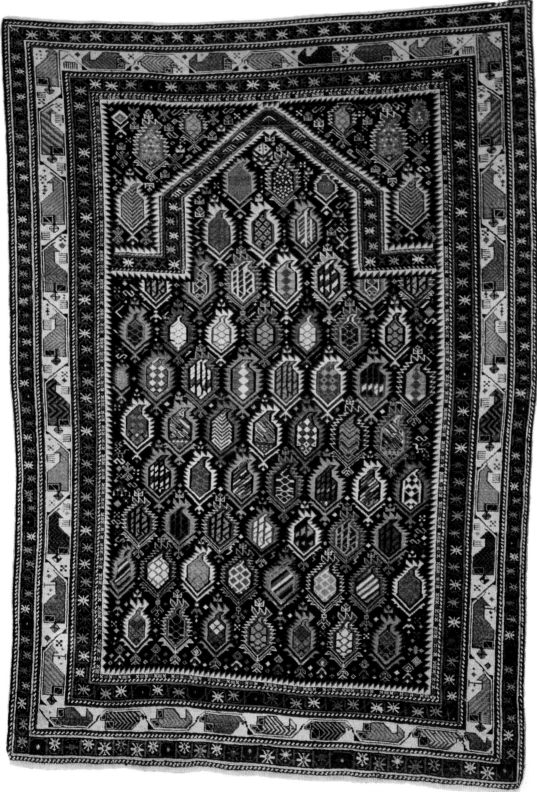

*Maraseli prayer rug with botehs; borders with stylized
bunches of grapes. Northeast Caucasus, 19th century. Private collection.*

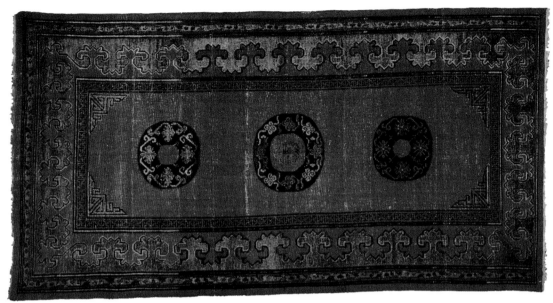

Three-medallion carpet, reciprocating trefoil border.
Chinese Turkestan, early 19th century. Private collection.

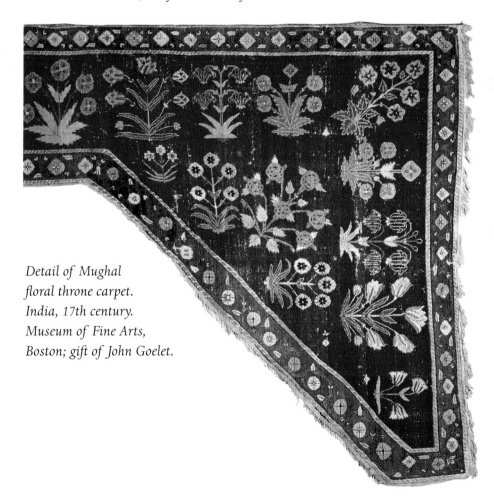

Detail of Mughal
floral throne carpet.
India, 17th century.
Museum of Fine Arts,
Boston; gift of John Goelet.

Chintamani fragment. Turkey, 16th century.
The Textile Museum, Washington.

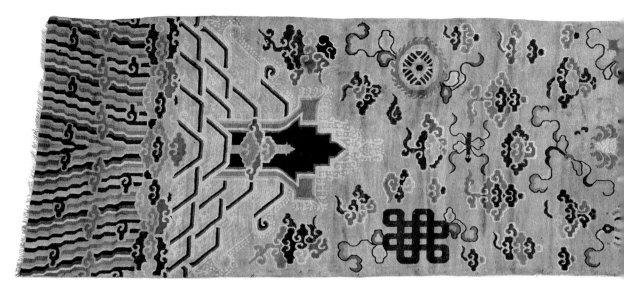

Chinese runner with water and mountain, cloud bands and numerous other symbols. 19th century. Private collection.

Symbols from a Chinese carpet. 19th century. Author's collection.

Parasol

Canopy

Wheel of the Law

Chou

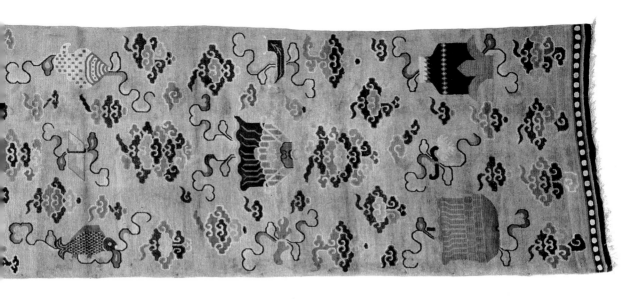

Symbols from a Chinese carpet. 19th century. Author's collection.

Fish

Chessboard

Knot

Cloud bands and books

Plum blossom

Peony

*Symbols from a Chinese carpet.
19th century. Author's collection.*

Bat

'Hand of Buddha' (citrus medica)

*Composite flowers
(pomegranate, prunus, peony)*

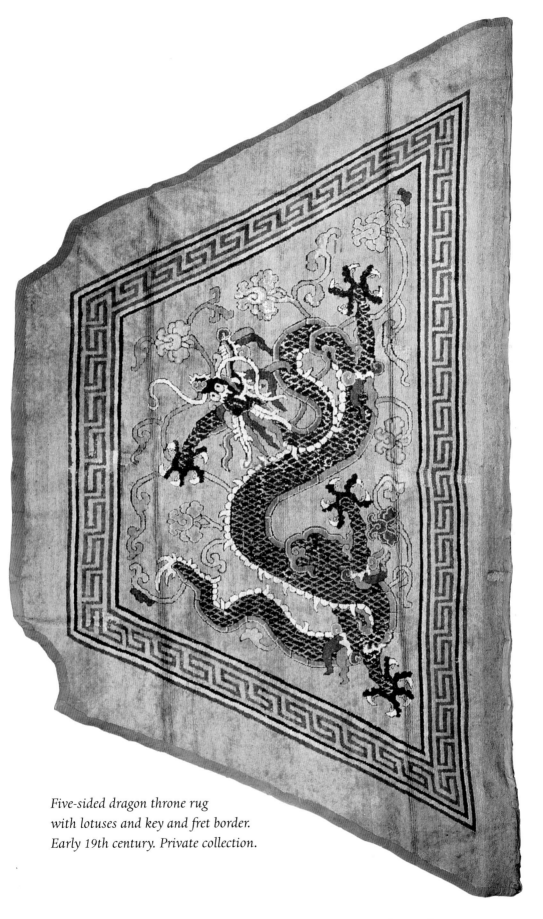

Five-sided dragon throne rug
with lotuses and key and fret border.
Early 19th century. Private collection.

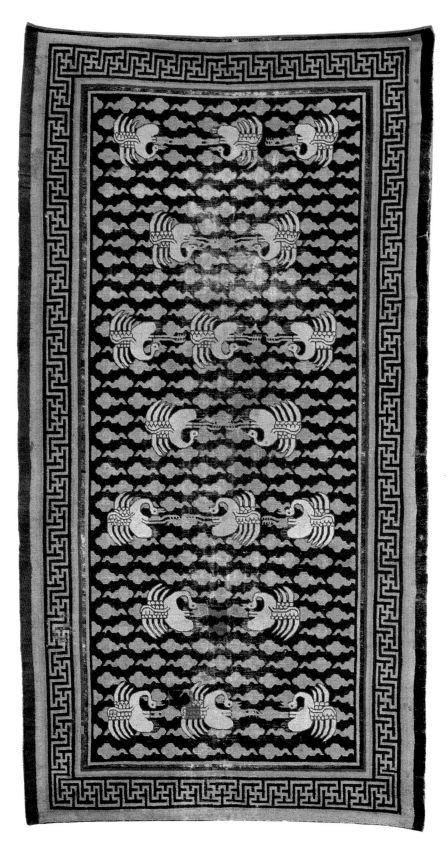

Cranes and clouds.
China, 18th or
19th century.
Private collection.

Middle Eastern
and
Turkoman Symbols

Capitalized terms are illustrated.
Terms in common use that are incorrect or questionable are placed in quotation marks.

Some Dates and Events

Dragon and phoenix. Turkey, 15th century.

After the collapse of Parthian rule early in the third century AD, the **Sassanids** (or Sassanians) under Emperor Artaxerxes held power in Persia until the mid-seventh century. A few Sassanid motifs survived in later carpet symbolism.

The **Huns** (Hsiung-nu) invaded Europe from Central Asia in the fourth century AD. Short, frightful, shabby nomads, prodigious mounted archers, they all but lived on their tough little horses. Having subdued northern China, they turned west into European Russia, Central Europe and Germany, driving the Goths and other tribes before them into Roman territory. They are cited here primarily to situate them in the chronology. **Attila** (c. 406–453), 'the Scourge of God', a ferocious dwarf, ruled from 434, at first with his brother, whom in due course he murdered, and then alone, making his capital in Hungary. The Romans successfully pushed him back from Gaul and Italy. During his nuptial excitements in 453 he succumbed to an unquenchable nosebleed. (Or perhaps he was done in by his bride, Ildiko.) After his death his empire crumbled.

Mohammed, born c. AD 570 in Mecca, founded Islam, meaning 'Submission' (to God's will). The Muslim calendar dates from the Hegira, his transfer in 622 to Medina, where he died in 632. He was about 40 when an angel told him he was the messenger of God. Thereafter he received frequent revelations which, transcribed, constitute the Koran. It, together with the *Sunna*, moral sayings and anecdotes, make up a body of religious and secular law. Islam accepts much of Judaism and Christianity, including their prophets: After Adam, Abraham is considered the first Muslim. Jesus, although not accepted as divine, is called Messiah. The fervour inspired by the 'Seal of the Prophets' led his followers to unify Arabia, and within a century to create an

empire comparable to Rome's, including a prodigious cultural flowering.

The **Seljuks**, a Turkoman (or Turkic, both terms being Chinese) people from Central Asia, moved west in the eleventh century. They captured Persia in 1038, making Isfahan their capital. They defeated the Byzantines in 1071, after which their fellows poured into Anatolia. The Seljuks created magnificent carpets, ceramics and metalwork, and developed the angular Kufic calligraphy (see page 98). Their empire disintegrated in the twelfth century and was overrun by the Mongols in the thirteenth.

Genghis Khan (previously Temujin; c. 1162–1227) was elected head of the *Tatar* (or Tartar) — partly Turkic — **Mongols** in 1206. An animist, he was convinced that God had designated him to rule the world. He conquered parts of China, the territory from India to the Caspian, and Southern Russia, destroying hundreds of cities and torturing and massacring their inhabitants: a million in Baghdad alone, for example.[15] He drove the Ottoman Turks from Central into Western Asia, which in turn helped disperse the Greeks and their high culture around Europe. His son Ogdei (1227–1241) pushed the Tatar realm outward, followed by **Kublai Khan** (1259–1294) who, from China, ruled over most of Asia and the Middle East except for India. His court was magnificent, belying his nomadic background. His successors in Persia bore the title of Ilkhan, and embraced Islam.

Mongol rule in China, which had become opulently decadent, was uprooted in 1368 by the **Ming Dynasty**, founded by a Buddhist priest turned revolutionary.

The **Golden Horde** (mid-thirteenth century) was the army of Genghis Khan's grandson, Batu Khan, and his successors, and was so called (*altun ordu* in Tatar) from the colour of his tent. It passed through Russia, killing and destroying, into Poland, Hungary and Silesia, only to be crushed in 1395 by Tamerlane.

For **Tamerlane** (Timur Leng, c. 1336–1405) see *Chintamani* in the text. A Muslim, he claimed to be Genghis Khan's great-great-grandson.

[15] 'Man's greatest joy is to defeat and rout his enemies, seize their possessions ... reduce their loved ones to tears, ride their horses and ravish their women', he opined.

His successors, the **Timurids**, gained and eventually again lost an empire extending from India to Turkey. During the fifteenth-century Timurid Renascence carpets and other arts, supported by the court, attained magnificent levels.

In the late thirteenth century Safi al-Din (d. 1334), a Sufi mystic, succeeded to the leadership of a Shiite religious movement based in Ardebil, which he developed and extended. His successors, the **Safavids**, dominated Persia, Syria and Eastern Anatolia.

In the fifteenth century the Safavids turned to conquest. Eventually they defeated the Turkomans and unified Persia under theocratic rule. The centuries of stability and wealth that followed led to a splendid flowering of textiles — the apogee of Persian carpets — books, manuscript illumination and ceramics, which reached its peak under Abbas I 'the Great' (1588–1629). See *Shah Abbas Palmette* in the text.

Afghan invaders overthrew the Safavids later in the seventeenth century, followed by Karim Khan Zande and Nadir Shah, who conquered India, looting the Peacock Throne. The **Qazar** dynasty from Azerbaijan then conquered Persia, Georgia, and the Caucasian provinces later lost to Russia. In 1925 came the **Pahlevis**, and then, after the fall of the last Shah in 1985, the present ayatollahs.

The **Ottomans** (or Osmanlis — followers of Osman I, c. 1300) had been designated defenders of the Byzantine frontier by the Seljuks. This embroiled them in constant fighting. They became by degrees dominant among the Turkomans of Anatolia from the late fourteenth to mid-fifteenth centuries. Constantinople fell to them in 1453. Their empire eventually comprised much of southern central Europe, the Middle East and north Africa, carrying with it their high culture — fully as refined as Europe's — of which the Topkapi Palace and the Blue Mosque are emblematic. Under **Suleyman I** 'the Magnificent', who ruled from 1520 to 1566, the Ottoman empire attained its broadest expanse and highest artistic flowering.

Ottoman expansion was halted at Lepanto (1571) and Vienna (1579 and 1683). There followed centuries of slow decline. Hungary, Azerbaijan and the Crimea were lost, and later Greece. The emaciated 'sick man of Europe' was finally secularized and rejuvenated in the 1920s and 1930s under Kemal Ataturk.

Animals

Abstract or Composite Animal

There is little difference in rug design between a *Dog* and a generalized quadruped abstraction. The head is often reduplicated.

One sees similar combinations of animals in African and other primitive art.

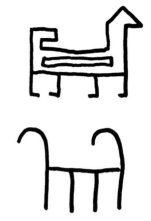

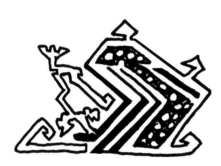

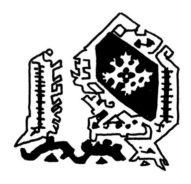

Animals Fighting

Sometimes just pictorial, but also symbolic of the conflict between the spiritual and the material.

See also *Dragon and Phoenix.*

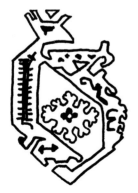

Camel

An everyday tribal subject; also a basic form of wealth, suggesting prosperity. Typically, camels form part of a bride price, and thus often appear in dowry rugs.

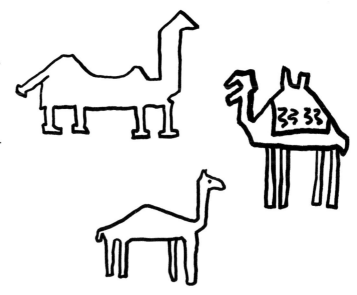

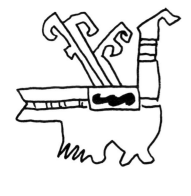

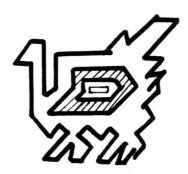

Celestial Creature

Recognizable because flames appear from flanks or shoulders.

Dog

The motif suggests the relationship between a dog and its master: dependence, trust, fidelity and defence. Dogs are unclean for Muslims, and thus not allowed as pets, although welcome for guard or hunting purposes. However, they are clean for Zoroastrians, chasing away evil spirits.

In Persia it is particularly the hunting dog, pursuing lions or other quarry, that one sees represented.

Dragon

In the Middle East a malicious creature, unlike the benevolent dragon of the Chinese tradition (see page 115). Brought by the Mongols, it presumably changed character as it was filtered through the bipolar adversarial world-view of Zoroastrian Persia, representing the struggle of light against darkness, the spiritual against the material. In Persian rugs the dragon or *ajdaha* may be schematized, particularly as a border pattern, into a simple Z or S.

Armenian folklore and Armenian rugs are rich in dragons (*vishaps*), which may be kindly as well as evil, going back to pre-history. Early Caucasian dragon carpets may have been woven by Armenians.

Caucasian flatweave dragon rugs are called *silehs* in the trade, but locally the term describes a bird design.

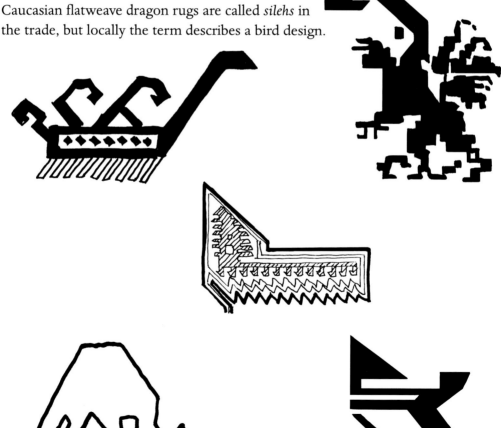

Dragon and Phoenix

Often symbolic of the conflict between the material and the spiritual, like the lion and the unicorn. The motif first appears in Chinese art. Adopted by the Timurids and Safavids, it reappears in stylized form in seventeenth- and eighteenth-century Caucasian carpets.

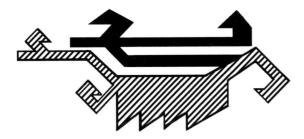

Horse

A horse may be confused with a *Dog* in some versions. The horse was constantly present in tribal life, closely linked with its owner. Among some Central Asians, a horse, together with its saddle, was buried near its master to be available on his final voyage. In mythology generally, the stallion suggests vigour and power.

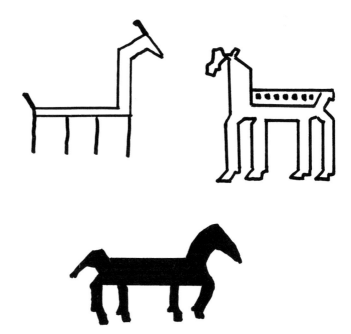

Man

May represent a male or female member of the weaver's family or of the family that is commissioning the carpet. Human symbols tend to appear on tribal rugs, notably Caucasian, and on Persian and Kurdish carpets. See *Hands on Waist*.

Caucasian rugs of Armenian origin often show human figures, sometimes dancing. On occasion the costume worn permits attribution to a particular village.

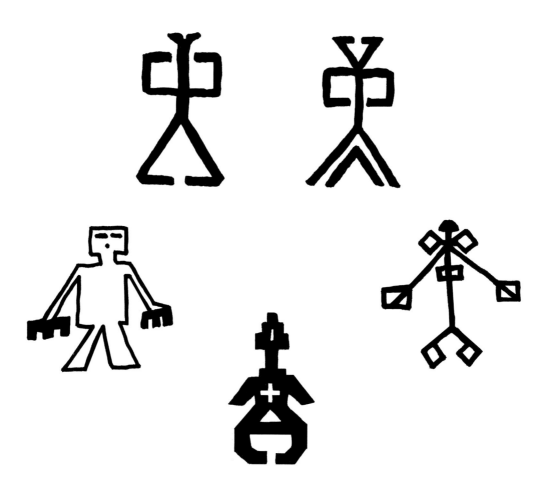

Ram's Horns (kotchak)

This universal symbol of power and virility is older than Islam, going back at least to the Scythian 'animal style' and the ancient Egyptians. Four pairs linked to the four points of a diamond are called in Anatolian rugs *kaikalak*, and in Turkoman rugs *vurma*; two pairs are called the 'birth symbol'. A variation used by the Tekke (see *Gül*) is called *karaly gochak*: 'ram with a black patch'.

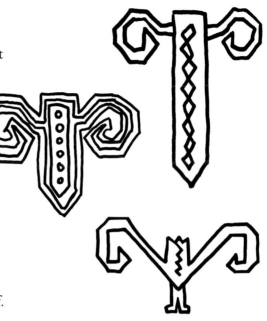

Ram's horns are sometimes called the 'scroll' motif or, particularly in Turkey, confused with the *Hands on Waist* motif.

Scarab

An ancient Egyptian motif; in English, the dung beetle.

Scorpion

Perhaps indicates courage, as it also does in astrology, since it will stand its ground and sting. Also a talisman against attack by a scorpion, a constant concern in a nomadic environment.

Serpent

Presumably a talisman against snakebite. It is also often associated in mythology with the *Tree of Life*, usually as a guardian.

'Tarantula'

Perhaps a Mongol talisman against attack by a tarantula; quite possibly, however, just a geometric motif.

Turtle or Tortoise

In some contexts implies worldly wisdom, since it lives both in water and on land. There was an ancient tribal belief in Persia that the earth was disk-shaped, and was supported clear of the surrounding waters on the back of a huge turtle. Similar beliefs were held by the Mongols, some Hindus and Chinese, and many other peoples.

This cosmophoric function of the turtle derives from its look of being solidly planted on its four feet.

Birds

Abstract or Composite Bird

A universal subject in art. In its most stylized form it resembles a hook.

One variation found in southwest Persia is the stylized *Cock*.

'Bird' Ushak

Not actually birds. This motif seems to be composed of arabesque palmettes, mutated into a solar wheel, representing the four directions and four winds.

Bird of Paradise

A fantastic creature, often seen in garden carpets. It may suggest paradise.

Cock or Rooster (murgi)

Highly venerated by Muslims; Mohammed called it the enemy of God's enemies. It summons the faithful to prayer, and thus may remind them to obey the Koran and resist temptation.

It is a sun symbol in most cultures, whence its use on weather-vanes, suggesting the dispelling of night, as well as glory and rebirth.

In south Persian tribal carpets, the *murgi* is believed to offer protection from the evil eye.

It is also a Christian symbol, and in Armenian rugs signifies faith and fertility. The word in that language means 'light-bearer'.

Eagle

In many cultures, suggests power, e.g., as a royal symbol in ancient Rome.

The extraordinary 'eagle' or 'sunburst' (or *Chelaberd* or *Chelabi*—from a town in southern Karabagh) Kazak design could be a complex flower motif or could derive from the double-headed eagle of heraldry. If the origin is indeed heraldic, there is little reason to believe, as is sometimes asserted, that it derives from the Russian imperial double eagle, since the theme is far older than that. In some traditions the double-headed eagle guards the entrance to paradise. P.R.J. Ford (see Bibliography) demonstrates a possible derivation from early Caucasian dragon carpets.

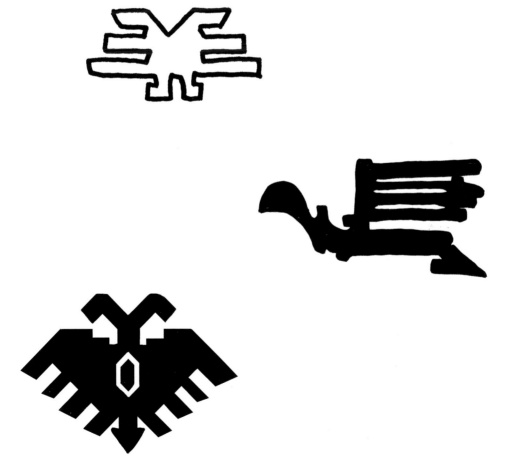

Frawashi

A rare Zoroastrian symbol of Ahura-Mazda or Feruhar, the chief deity of that religion. The Persians, overcome by the Arabs in the seventh century, generally forsook Zoroastrianism for Islam. The Parsees, however, Zoroastrian refugees, established themselves in Bombay, while other Zoroastrians survived in Kirman.

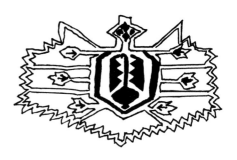

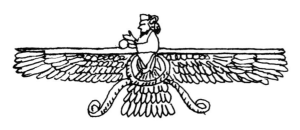

From a Persepolis relief

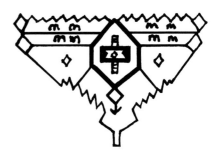

Goose, Duck or Swan

Both in rug symbolism and mythology generally, the goose is close to the swan, and suggests conjugal fidelity. For the Sufis the duck possessed enchantment, since it lived on land and water and in the air.

Parrot

Suggests escape from danger and, when green, divine protection.

Genghis Khan's pet parrot is traditionally said to have saved him by imitating his voice to lead astray a band of pursuers.

Parrots, loving sugar, are called 'sweet-toothed ones' in Persian poetry, and thus refer to sweet-talking flatterers.

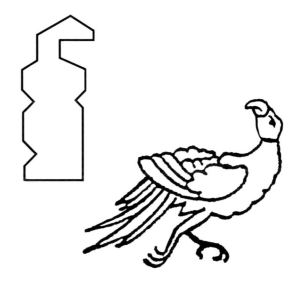

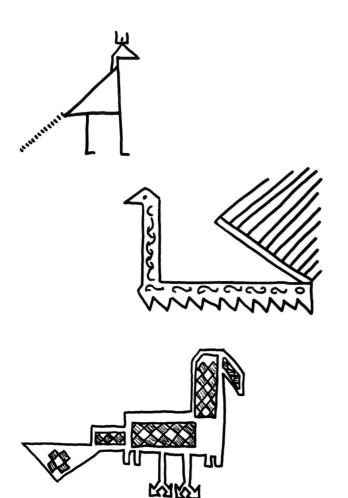

Peacock

Immortality.

In Persian rugs, divine protection. Venerated by the Yezids, whose religion is a mixture of Islam, Zoroastrianism and Christianity.

Phoenix

The 'good' aspect of the *Dragon and Phoenix* duality. In Arabic tradition it would only alight on the mountain of Qaf — the axis of the world.

The phoenix of the Greeks is an adaptation of the Egyptian *bennou*, associated with the annual flooding of the Nile, and thus implied regeneration. So did the other (Ethiopian) source of the Greek mythological gorgeous bird that was consumed and reborn in fire.

The Chinese phoenix or *feng-huang* is described in the Chinese section on page 126.

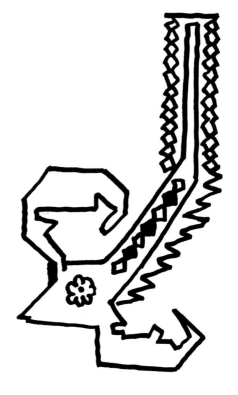

Simurgh

A mythical Middle Eastern bird (see page 00 in the Introduction). It was the legendary king of birds, a variation of the phoenix; also called *simurv, senmurv, arga rokh* (which carried Sinbad), *homa* and *rakhamat*. In Sassanian lore it dispersed plant seeds. The word itself derives from Avestan *saena marega*, 'eagle bird', based on pre-Zoroastrian tradition, perhaps in turn deriving from the *anzu*, a giant bird in Sumerian mythology. In some depictions it is a combination of an eagle, dog and lion, merging with the griffin, an ancient and rich symbol signifying, *inter alia*, the ascent of Alexander the Great to heaven.

In the Introduction I describe Farid ud-Din Attar's *Mantiq ut-Tair* (The Conference of the Birds), an immensely influential Sufi parable of the spiritual life. (It is, for instance, a source for *Don Quixote* and *William Tell*.) A flock of pilgrim birds yearn for their king, the *Simurgh*. They elect the hoopoe to guide them across the five valleys and two deserts that lie on the way to his palace. Many of the birds falter: The self-centred parrot and peacock beg off on the grounds of other concerns; the goose and bittern must remain near water; the nightingale fancies that its duty is to teach the mysteries of love and sing rapturously to the rose. The hoopoe, however, disdains these excuses.

The birds cross the valleys of the quest for truth, of love, of mystical knowledge, of detachment and of unity; and thereafter the deserts of astonishment and annihilation. On the terrible journey many are killed or lost. Finally, the survivors reach the palace, only to find, entering the great hall, that they, *si murgh*, 30 birds, are the object of their own quest: Divine reality is within ourselves.

Sunbird

Considered to represent the metaphysical sun, and thus often placed on top of the *Tree of Life* or world axis.

A version of the sunbird, part lion, part dog, and part bird, appears as early as Sassanian textiles of the sixth and seventh centuries. It is sometimes shown attacking serpents or other symbols of evil. Originally double-headed with an aperture in its body for the sky gate, the sunbird became over time increasingly stylized and rearranged. It thus sometimes appears as a single-headed bird, or a combination of stylized heads. The sunbird/snake combat resembles that of the *Dragon and Phoenix*.

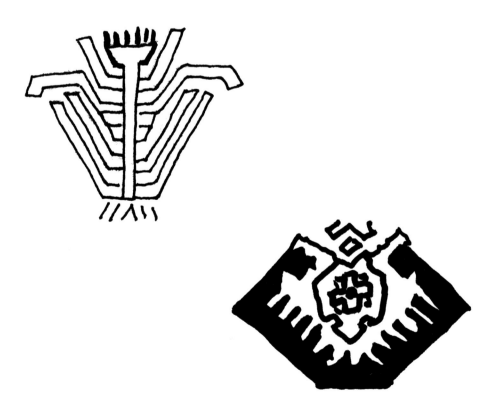

Flowers

Apple Blossom

Invokes productive fertility.

Arabesque or Tendril

The basic unit of the arabesque, a favourite Islamic decorative theme, may be described as a split leaf seen in profile, called *islimi* in Persian. Derived from a Sassanian motif, it developed under the Abbasids in the ninth and tenth centuries, and matured under the Seljuks in the twelfth and thirteenth. It became central in Turkish and Persian carpet design only after the fifteenth century. In its fascinating fully developed form one sees interlaced lattice systems of spiralling stems or tendrils, which project secondary tendrils ending in palmettes.

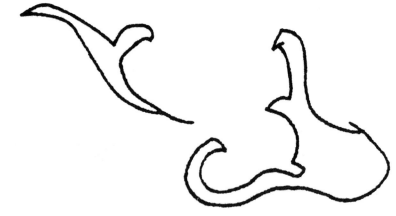

(Wild) Carnation

In Turkish carpets, wisdom and happiness. This motif is woven by new brides as an expression of love and loyalty, as well as to symbolize peace and the gardens of Paradise.

Chenar

Suggests the purification of the worshipper before Allah, just as in spring the chenar tree, which is often planted in mosque enclosures, sheds its bark.

Hyacinth

Regeneration, fertility.

Favoured in Ottoman court carpets, and then in village rugs, chiefly Turkish.

Iris

A flower of spring; for some Persians it suggested religious liberty.

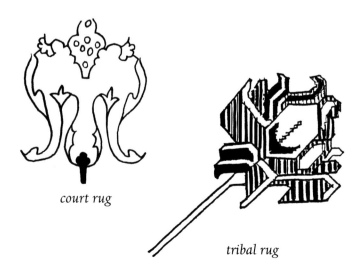

court rug

tribal rug

Lily

In mythology generally, the lily suggests purity and spirituality.

Lotus

One of the richest and most ancient symbols, discussed further in the Chinese section. In ancient Egypt it was a holy flower, invoking the ideas of purity, rebirth and immortality.

Perhaps also carried west by the Mongols, it entered into the Middle Eastern design vocabulary.

See also *Palmette*.

Mina Khani

A traditional floral design, typical of Western Persia. One variety of flower is placed at the interstices of a trellis-like network of stems, while in the centre of each section is placed a different, often cruder, flower.

The term may come from *aina khaneh*, 'hall of mirrors' or might mean 'jewel of the khan'.

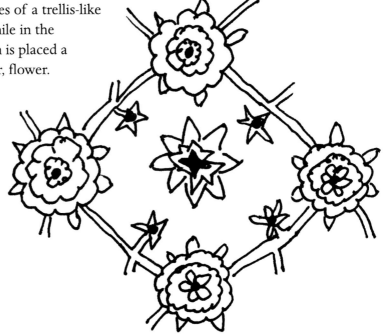

Narcissus

In Turkish lore, the narcissus is the leader of the garden, bringing order.

In Persia it may signify resistance to adversity.

Palmette

The palmette suggests a lotus or other flower seen from the side, or a stylized palm leaf or clump of leaves, just as the rosette resembles a flower seen from the top. It may imply wealth and honour.

The lotus palmette motif is found in the art of the Assyrians, the ancient Egyptians, and the Greeks of half a millennium BC. Alexander the Great carried it to Central Asia, where it became widely used in architecture. From there it migrated to China.

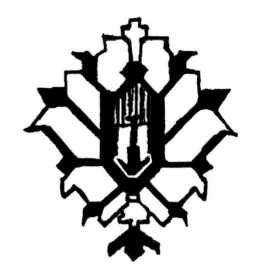

'Shah Abbas' Palmette

Named after Abbas I, 'the Great', the third Safavid ruler of Persia (1588–1629),[16] who created splendid court carpet workshops in Isfahan, his capital city.

A full Shah Abbas design may include cloud bands, leaves and vases, linked by tendrils.

[16] His son Abbas II, a popular ruler, blinded his brothers to avoid dynastic squabbles. He assembled a harem of virgins, with whom he spent entire years, to permit enjoyment without infection, which nevertheless felled him in the end. *His* son, Shah Suleiman, cleared the streets when he took his 800 ladies on outings, to foil oglers.

Peony

Summer, power.

Plum Blossom

Symbol of youth and spring,
and of a newly wed bride.

Poppy

The opium poppy suggests bewitchment and sleep.

 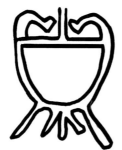

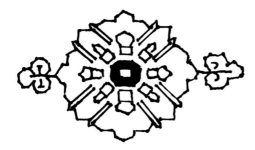

Rose

In mythology generally, the rose implies mystery. The white rose suggests innocence, while the red rose often suggests passion and fertility, and the wild rose, yearning.

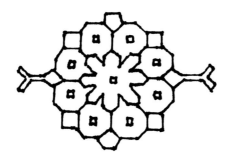

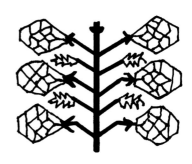

Rosette

A flower seen from above. The rosette is one of the
most ancient archetypes in Middle Eastern carpet
design. Some scholars hold that it is originally a solar
symbol.

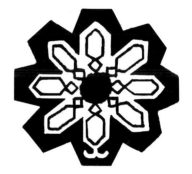

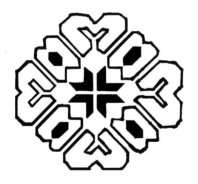

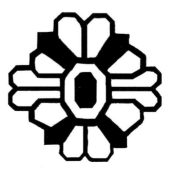

Tulip

A much-loved universal Ottoman motif, both in prayer carpets and elsewhere. It is believed to suggest prosperity.

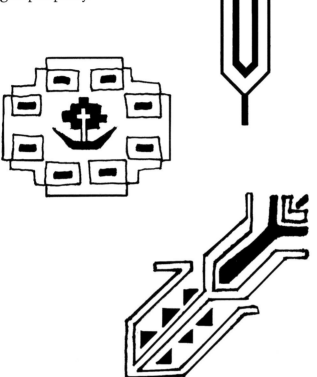

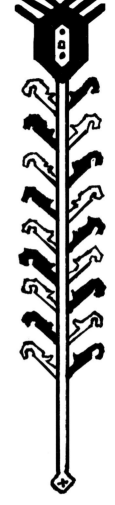

Ladik—the ancient Laodicea

Water Lily

There are two variations, one deriving from Egypt (illustrated) and another from China.

Suggests the rhythm of day and night, since it closes during the hours of darkness.

Trees

Cypress

Often found on funeral rugs. It suggests death and serenity, but also, being evergreen, rebirth.

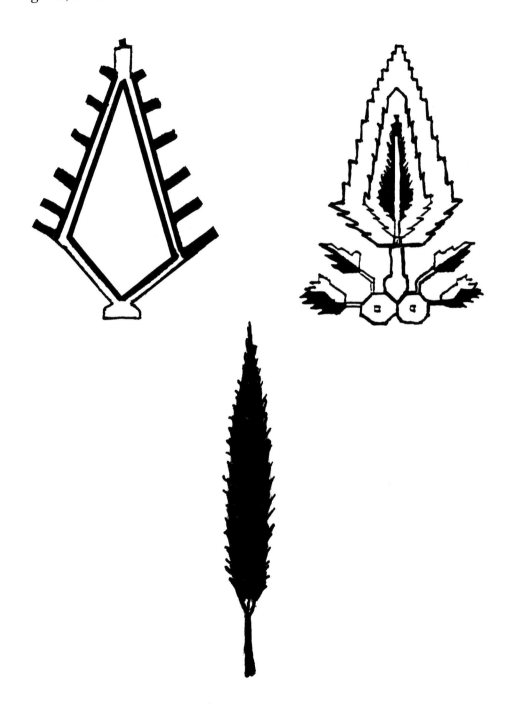

Leaf

Implies endless regeneration, and thus immortality.

The feather-like or pennate leaf (*saz*) was a central feature of the *saz* style that flourished in the sixteenth and early seventeenth centuries. Typically it included *hatayi* ('Cathay'—China) elements, such as lotus and peony palmettes and intricate arabesques.

Palm

Rarely seen in carpets, except the classic Cairene Egyptians, woven under the Mamelukes.

Pomegranate (fruit)

An ancient symbol of fertility, found throughout Asia and the Middle East.

Tree of Life

One of the oldest and most universal symbols of mankind.

It supports the sky, and provides a path from earth to heaven. In different cultures it is called by names such as *haoma, asherak, yggdrasil, irminsu* or *asvattha.*

Thus, one often sees it in prayer rugs, as a reminder of the passage from this existence into a higher life.

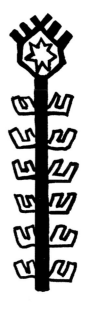

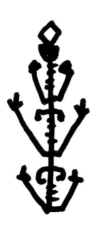

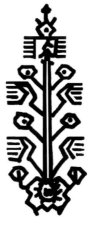

Vine Leaves

A familiar theme in urban
and village carpets.

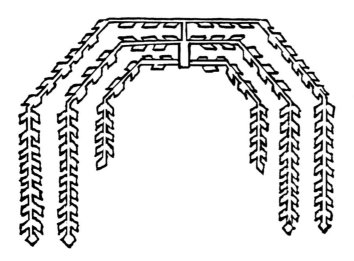

Willow

Found in cemeteries.

Other Symbols

Agrafe

This upward double latch-hook alternates with the *Ram's Horn* motif in crowning a *Mihrab*. Either may mutate into doubled bird or animal heads, or flowers.

I offer the suggestion that the upward-curving version could be called by the French term *agrafe*, 'hook', in distinction to the downward-curling ram's horn. The *agrafe* in a *Mihrab* echoes the crescent often placed at the peak of mosque domes.

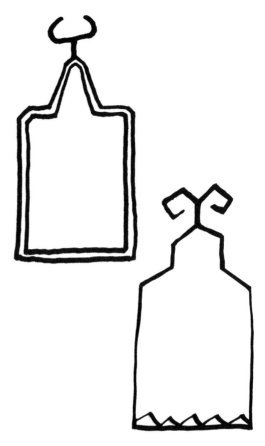

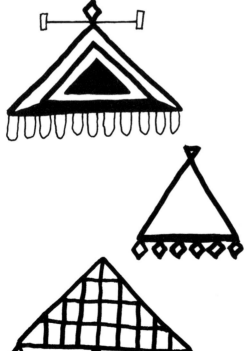

Amulet (muska)

An apotropaic triangular talisman, intended to avert the evil eye, frustrate devils or bring good luck. The design evolved from that of a pouch for carrying religious material, such as Koranic texts or relics. This is one of the symbols actually understood today by most weavers. It is universal in Central Asia,[17] and widely found elsewhere. All over the world charms or emblems are worn around the neck.

[17] An enterprising British (Parsee) writer, Sheila Paine, scoured the region looking for the source of a particular variation, before finally running it to earth in Razgrad, Bulgaria. *The Afghan Amulet*; see Bibliography. In Peshawar she encountered a hotel that proclaimed that all its toilets had 'flesh attached'.

Boteh

Also *boteh-miri*, *mir-i-bota*, Serabend motif, and *nakshi-badam* (almond-nut)

Known in the west as the Paisley, flame, pine, pine cone, palm cone or pear design, this curiously satisfying shape is one of the eastern hemisphere's most ancient and universal symbols — occurring in the Pazyryk barrows in the fifth century BC. Its appearance in rug symbolism was comparatively late.

The word derives from Persian 'cluster of leaves' or 'bush'. It often represents fertility. A *boteh* containing smaller ones may be called 'mother and daughter'.

In different places it may suggest other ideas, including perhaps the following:

1. In Egypt the *menath* form, associated with the womb, was a container or carrier and signified joy or health, and perhaps fertility.

2. For the ancient Greeks, it was a stylized eye, to avert the evil eye.

3. In Persia, where the motif is particularly widespread, especially in the Serabend district, it is a Zoroastrian flame symbol.

4. Schuyler Cammann (see Bibliography) held that it was a variation of *Sunbird*, guardian of the gates of paradise in pre-Islamic mythology.

5. In Buddhist countries it represents a leaf of the Bo-tree, sacred to Buddha.

6. In Pakistan it can be a stylized *Palmette*. One sees it everywhere in Kashmir.

7. In Islamic countries generally, it may suggest the soul and immortality.

'Candlestick'

A characteristic motif in Turkoman 'Khatchli'—'cross'—doorway rugs (properly, *ensi*). It is called *insi-kush*, 'youngest brother of the bird', signifying perhaps that the host is humbling himself before his guests, called 'birds of the desert'. If not a stylized bird, the motif might conceivably be a simplification of the tree patterns in Persian garden carpets.

It does not, of course, have anything to do with a candlestick.

Checker Pattern

Probably a stylized sun symbol, based on an earlier design — a circle crossed by diagonals. Nomadic weavers avoid curves, which are hard to render, and tend to turn them into sequences of straight lines.

Chintamani

The *tamga* — sign or brand — of Tamerlane (1336–1405).

Ruy Gonzalez de Clavijo, a Spanish envoy to Samarkand, recorded that Tamerlane placed this device on his coinage and property. A tradition has it that during the capture of Samarkand, Tamerlane dipped three fingers in the blood of an enemy and pressed them on the door of a mosque to indicate that he was seizing it personally. 'Chintamani' may mean 'footprint of China'. The motif is also called the badge of Timur or the ball-and-lightning pattern.

The two bands very possibly derive from the tiger-striped robes of earlier rulers, and indeed are called 'tiger stripes' in Turkish. Alternatively, they could be *Chi* variants, but certainly *not* the 'lips of Buddha', as they are sometimes called. The three balls probably derive from an ancient

Buddhist religious symbol, the *mani,* or wish-granting jewel. This occurs as the 'nine jewels' or *nava ratna*; the 'seven jewels' or *sapta ratna*; and the 'three jewels' or *tri ratna*: Buddha, *dharma* (law), and *sangha* (community). The *mani*, in the sense of 'free from stain', also signifies purity. In Chinese art it often appears as a flaming pearl, deriving perhaps from a still earlier Hindu symbol.

The *chintamani* appeared in rug design in the period of Selim I 'the Grim'[18] (1465–1501), and thereafter became widespread in Asia Minor, presumably as a symbol of rulership and power, not specifically of the invader Tamerlane. Visitors to the Istanbul Hilton may be surprised to find it on the walls of the ground floor — the new touristic invasion borrowing the insignia of the old.

[18]'Grim' because *inter alia* he murdered his father, brothers and nephews.

Timur was born south of Samarkand to a Mongol clan chief in 1336. After his right leg was maimed, he became known as Timur-i-Leng — 'the Lame'. From 1380 on, he overwhelmed Persia, Syria, the Caucasus and Baghdad, which he destroyed, leaving a pyramid of 100,000 skulls. In 1402 he crushed the Ottoman Army and captured the Emperor Bayazet. A pitiless butcher, he froze 20,000 of his own men pushing over the Hindu Kush into India, where he left five million victims, returning with 10,000 pack animals laden with booty. He established a terrible order in his realm, facilitating commerce, and shipped back artisans and scholars to his capital, Samarkand, which he transformed into a wonder-city of gorgeous palaces, mosques, water-gardens, libraries and academies, filled with art and culture. When the doorway of the Bibi Khanum Mosque struck him as inadequate, he hanged the builders and assigned new ones. Although illiterate, he was quite learned, well-informed on science and architecture, a keen chess player, and fond of carpets.

Of all this horror and splendour, only ruins — and the *chintamani* — remain.

Chou or Shou

A Chinese good luck symbol that migrated into the Middle East.

Cloud Band

See *Cloud Band* on page 112 in the Chinese section.

Cloud Collar

Surrounds the sky gate. (See pages 10–11 in the introduction, and page 113 in the Chinese section.)

It appears in Persian classical carpets, having been borrowed directly from the Chinese.

Comb

With this instrument the weaver is constantly tamping down the work just completed.

It is sometimes maintained that the comb also reminds the worshipper of the duty of cleanliness in preparation for prayer, which seems far-fetched, or that there is a reference to rain (as in american indian sign language).

Cross

An ancient symbol in many cultures for the four cardinal directions, thus suggesting the sun.

A cross as such is without religious significance for Muslims, and is indeed antipathetic.

Still, when the motif appears modestly inserted in the field of a Caucasian rug, one can sometimes imagine a Christian weaver, perhaps an Armenian, leaving a trace of his faith.

See also 'Khatchli' Design.

Diamond or Lozenge

It has been conjectured that this omnipresent motif in Anatolian kilims is a male triangle attached to a female triangle, and thus signifies creation. There are doubtless many interpretations. A diamond surrounded by hooks is called in Turkish *kirkbudatz*, 'forty branches'.

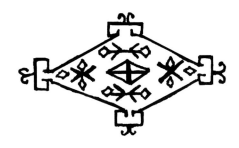

Among some semi-nomadic pastoral (*terekme*) tribes of Azerbaijan, a favourite symbol is a large diamond, signifying woman. Smaller diamonds within the large one signify a pregnant woman or her progeny. A diamond within a square depicts a woman near a fireplace.[19]

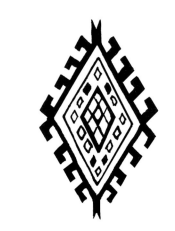

[19]According to Academician Kubra Alieva, in a paper at a 1983 conference in Baku on Azerbaijan carpets.

Ewer (ibrik)

This motif suggests purification, and is a reminder of a devout Muslim's obligation to wash and pray five times daily. It is thus frequently shown in or near *Mihrabs*. When it 'hangs' from a *Mihrab* it may be inverted, perhaps because it was assumed to have been emptied in ritual ablutions.

Gül

These are traditional octagonal devices of Turkoman tribes (properly *khalk*— 'people'). The word means 'flower' or 'rose' in Persian, and it is possible that they derive from early flower symbols. Another view claims they echo early totemic tribal bird-forms. The motif is sometimes, absurdly, called 'elephant's foot': *fil-pai* in Persian. Intermarriage and conquest confuse some identifications. A vanquished tribe would often adopt the *gül* of its conquerors. Thus, the Salor *gül* is sometimes used by the Tekke. Also, some Turkoman rugs with a given *gül* may be made for the market by a different tribe, like a Scottish tartan.

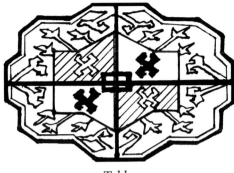

Tekke

There are secondary *güls*, called *nebengüls*, characteristic of each tribe, placed between the primary *güls*, but these are less easily recognized. Some technical studies distinguish between the *gül*, seen in tribal carpets, and a *gol*, or ancient quasi-heraldic symbol.

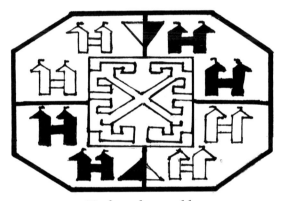

Tauk-nuska, used by various tribes

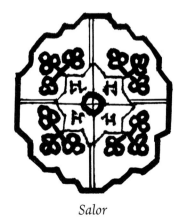

Salor

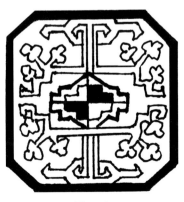

Ersari

Hand

One often sees a pair of hands on either side of a *Mihrab*, in the position where a worshipper will place them during prayer. Also, however, the hand is considered to possess magical properties, both in pre-Islamic iconography and since.[20] The 'hand of Fatima', Mohammed's daughter, appears frequently in Islamic decoration, and signifies the five key ideas, or pillars, of Islam: professing the faith, praying five times a day, the pilgrimage to Mecca, or *hadj*, and charity to the needy.

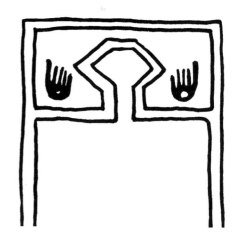

[20] 'Dr. Madzharov...shook his head..."They call it the hand of Fatima, but it is much older than Islam. It symbolizes the various meanings of the hand: the sincerity of man,...goddesses and protection."' Sheila Paine, *op. cit.*

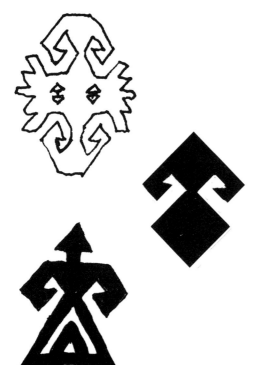

Hands on Waist

One should be careful not to confuse the *eli belinde* or *Hands on Waist* motif in Anatolian carpets with the *Ram's Horn*.

Scholars generally do not accept the conjecture that the *eli belinde* is an echo of a neolithic mother goddess cult that left traces in Çatal Hüyük, central Anatolia.

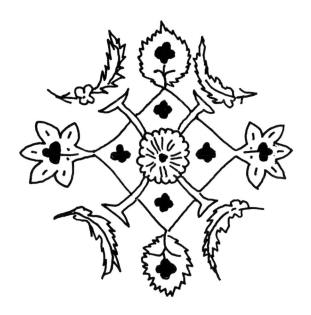

Herati or Ferahan Pattern

A much-loved design consisting of a rosette with palmettes and serrated ('lanceolate') or feathery ('pennate') leaves. These may be incorrectly called in French *mâchoires de lion*: 'lion's jaws'. The pattern repeats vertically, horizontally and diagonally. The serrated leaves in some Herati designs seem to resemble fish, and the pattern a water-garden, with canals and other aquatic themes. It has thus been called the *mahi* (fish) design by some Persians.

'Khatchli' Design

Means 'cross'. These Turkoman carpets themselves are properly called *ensi* (or *enssi* or *engsi*): 'door-curtain'. When in use, the fringe at the top is folded back, loops are added, and the rug hangs in the entrance of a Turkoman *yurt* (tent). Beneath it may be strung a fringe or *germesh* to keep out dust. A typical *yurt* can be 20 feet — about 6 metres — in diameter, and when disassembled constitutes one camel-load. Although some *'khatchli'* include *Mihrabs*, they are not ordinarily used as prayer rugs: It would be inconvenient to unhook one's door-curtain five times a day. There are, however, similar prayer rugs without loops, usually smaller and often with an identifying *Agrafe* motif above the *Mihrab*.

It is possible that the four panels originally represented the four gardens of paradise, but not, as is sometimes suggested, that the cross reflects the influence of Nestorian Christianity.

The *ensi* bespeaks the virtue and duty of hospitality: 'Come in…be my honoured guest', it seems to say.

See also *Candlestick*.

Knot

Destiny.

In Islamic tradition, knots may be tied to ward off evil, although a pilgrim entering Mecca must have no knots in his garments.

The Koran refers to sorcerers who tie magical knots and blow on them to cast spells.

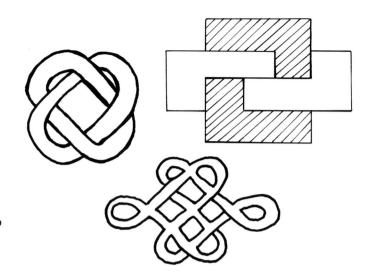

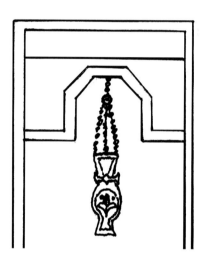

Lamp

Often 'hangs' in a *Mihrab*, and invokes the divine presence and paradise.[20] 'God is the light of heaven and earth. His light is like a niche containing a lamp', says the Koran (24:35).

[20] It has been suggested that originally, when there were opposing *Mihrabs* in one prayer rug, a lamp in one of them indicated the direction of Mecca. Later there might be lamps in both *Mihrabs*.

'Lesghi Star'

A tribal motif not necessarily confined to Lesghistan, which borders Daghestan. It also occurs in carpets from the Shirvan and Kuba districts, for example.

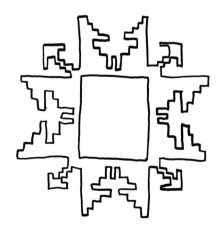

Mihrab

The prayer-niche in a prayer rug (also *sajjada, janamaz,* or *namazlyk*). It represents the corresponding feature in every mosque, which indicates the direction (*qiblah*) of Mecca, and suggests the gateway to paradise. The *mihrab* of a rug (not of a mosque) frequently contains a *Lamp* hung from the arch, which is often supported by columns. There is sometimes an opposite niche, which may result in lamps hanging toward each other. This can occur, rather touchingly, in *kis* dowry carpets. *Tulips* and *Ewers* may be found nearby. Five times a day, facing Mecca, the worshipper performs *salat*, touching the ground with his forehead, hands, knees and big toes. There is sometimes a square or *almuk* at the point where his head will touch the rug. (See also *Hand*).

The *mihrab's* upward-reaching effect suggests the progress of the worshipper toward illumination. A hint of paradise is often intended in the flower or garden themes found in the *mihrab*. It should be remembered that by no means all Muslims were fortunate enough to possess a prayer rug. It suffices to pray on anything clean. They come in double, triple and indeed multiple (*saff* or *saph*) versions. The latter may (often incorrectly) be called 'family' prayer rugs.

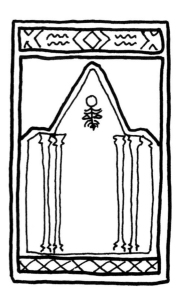

Numerals — Arabic

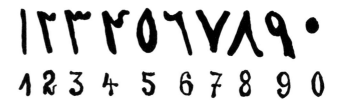

They do not infallibly indicate the date when a rug was woven, since a later copy may reproduce an earlier date. One should note that while Arabic script runs from right to left, Arabic numbers run from left to right. Sometimes the same date will be shown twice: once from left to right, and once from right to left, to create a symmetrical effect. Occasionally the first digit, or if it is a 0, the last, is omitted. The method of determining the date AD (or CE) from the Arabic (AH) date is described in the Introduction on page 15.

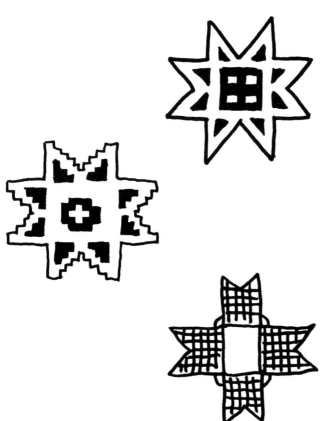

Star

A motif — superimposed rotated squares or triangles — that embodies thousands of years of tradition.

The eight-pointed star is an ancient emblem of spirituality: 'Mohammed's jewel'. It was also the star of the Medes and Persians.

The six-pointed Seal of Solomon or Star of David was adopted by the Muslims.

Both ordinarily appear only in tribal rugs.

Swastika
(pech or triskelion)

An extremely ancient symbol, one of whose interpretations is a rotating solar cross.

See also *Swastika* on page 128 in the Chinese section.

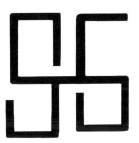

 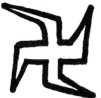

Syngyrme

An old Turkic amulet motif.

Borders

'Crab' (Harshang) Border

It is in fact a flower or palmette flanked by sprays of four smaller flowers.

Key and Fret Border

Kufic or Kufesque Border

Derived from angular Kufic Arabic script. See page 15 in the Introduction.

Reciprocating Trefoil

Sometimes called 'dogtooth' border. It can be found almost everywhere rugs are made. The more elaborated version, resembling a *fleur de lys*, may be called *laleh Abbasi* — 'Abbasi tulip', or *medahil* — 'doorways'.

Rinceau or Flower Meander

A universal theme from Europe to China.

'Running Dog' Border

A reciprocating latch-hook.

'Running Water' Border

'S' Border

See Dragon.

'Serpent' Border

Probably, curled leaves.

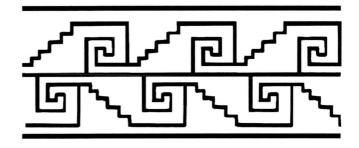

Tree of Life Border

See *Tree of Life*.

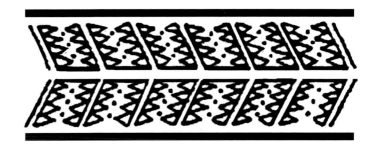

Waves and Foam (oblique lines)

In Chinese Turkestan this is believed to suggest philosophy overcoming adversity. It was derived from the Chinese. See also *Water* in the Chinese section.

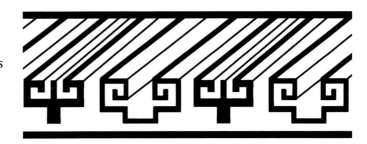

'Wineglass' Border

More properly, a calyx (from the inner part of a flower) and a serrated leaf.

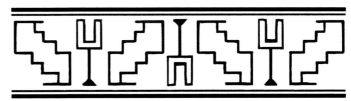

Chinese Symbols

The symbols in Chinese carpets are almost always more explicit and static than those found in Middle Eastern carpets. Many are rebuses, as though for 'I' one rendered a human eye, for 'you' a ewe — a female sheep—and so on. Being monosyllabic, Chinese is extremely rich in homonyms, so the same word, rendered as a rebus, can have many different meanings. Thus, 'success' may be represented by a sceptre, a piece of silver or a brush. For further examples, see *Bat* or *Deer* in the text.

Sometimes the theme of a rebus in a Chinese carpet is amusingly specific in a worldly sense, e.g., 'I hope to be promoted three grades in official rank.' Often it involves sentiments one might hear in a toast: long life, health, wealth, happiness, many children, and so on. For example, a note on a carpet in the Textile Museum in Washington observes that 'a proud white egret signifying purity stands in a lotus pool undefiled by the mud at the bottom. The corner motifs are "wish granting jewels." The official using the chair could, therefore, wish to rule with "undefiled purity."'
There are scores of religious symbols in Chinese carpets, including Confucian, Taoist and Buddhist (including Lamaist) motifs.

Kung Fu Tse, born in 551 BC, known as Confucius, taught in his Analects that society should be based on relationships of respect for the ruler, whose conduct must be exemplary, for one's family elders and for one's neighbours. The superior man was to be animated by virtue and propriety.

Lao Tse, traditionally the founder of Taoism, held in the *Tao Te Ching* that matters should be allowed to evolve in their own way, like water finding its own level. The ruler should not hope, or try, to alter the course of events through vigorous measures. Thus, the best government is the least government. An individual should not be a restless striver, and should hope for good luck, prosperity and long life.

Siddartha Gautama, born about 563 BC in present-day Nepal, known as Shakyamuni Gautama Buddha ('the Enlightenened'), taught the Four Noble Truths, that life means suffering, that suffering derives from passions or desires, that these may be extinguished in Nirvana, and that

this requires following the Eightfold Path, including right feelings and actions, together with the Five Precepts, including not killing, stealing, lying or indulging in lust.

Over the great passage of time these various teachings and practices, like those of most religions, became enormously elaborated and cluttered, riddled with symbolism, and jumbled together. (Zen contains Taoist and Buddhist elements.) Thus, a Chinese religious ritual, such as a funeral, may combine Confucian, Buddhist and Taoist aspects. This may seem odd, and yet the same is true in Japan, where Buddhism is superimposed on the ancient cult of Shinto.[21] So for the Chinese all three religious strains have to some extent merged along with their symbols, which permeate all their art, including carpets.

The wonderful 'Samarkand' carpets of Chinese Turkestan, including Khotan, Yarkand, Aksu, Ninghsia and Kansu, clearly show influences from both east and west, including elements such as the *Cloud Band*, the *Gül* and the *Ram's Horn*. The circles in a Khotan medallion carpet probably represent the lotus-pedestal in a temple on which is placed a seated statue of Buddha, symbolizing spiritual rebirth, flanked by two Bodhisattvas. All this is as one would expect, given that these places lay athwart the ancient trade route from Persia, Afghanistan and Samarkand to northwest China and Beijing. By the eighteenth century the Manchu court was consciously integrating East Turkestan and, indeed, Persian carpet styles into the traditional Chinese idiom, just as Shah Abbas had done earlier in the opposite direction.

[21] Before a Japanese funeral, the bereaved family negotiates with the Buddhist temple over the posthumous Chinese religious name or *kaimyo* that will be assigned to the deceased and displayed at the ceremony. A more substantial payment gains a name with more Chinese characters. For that matter, Christianity contains strong pagan relics: The Pope's title of Pontifex Maximus —'chief bridge-builder'— refers to an ancient function of the head of the Roman religion. He tossed little statues into the Tiber to propitiate the river-god for the drowned travellers he lost when bridges replaced ferries. And our Christmas rites were superimposed on the Roman Saturnalia, with Druidic elements added.

The Chinese have always liked specific numbers of things: the Eight Immortals, the Eight Treasures, the Eight Trigrams, the Eightfold Path, the Eight Ordinary Symbols, or whatever.

There are eight Chinese carpet symbols derived from Buddhism: the wheel of the law, the shell, the umbrella, the canopy of state, the lotus, the vase, a pair of fishes, and the endless knot.

The eight symbols of Taoism are the sword, the gourd, the crutch or staff, the lotus, the bamboo tube or wand, the fan, castanets and a basket of flowers.

The four pleasures of the literati—accomplishments of a gentleman—are music, symbolized by a flute; learning, represented by a book or scroll; a chessboard, and painting.

There are eight precious objects derived from the hundred antiquities in the old books of rituals. They include the pearl, signifying beauty and truth; the coin, signifying wealth; and two books, signifying study.

Colours also have significance in Chinese art: Red suggests joy, and invokes the phoenix, summer, the spirit and fire. It was the colour of the Ming dynasty. Green suggests wood, the dragon and spring; white: the tiger, autumn, and metal; yellow: again the dragon, earth, central China, and the Emperor; black: the tortoise (symbolizing long life), winter and water; and blue: the sky and serenity. In Khotan medallion carpets, the customary red background signifies, as it does in Buddhism generally, the world of the senses, masculinity and the sun, while the blue of the medallions suggests spirituality, the feminine and the moon.

A ribbon or fillet intertwined with an object indicates its importance or sanctity, like a wreath in Roman art, or a halo in Christian iconography. In the interest of simplification the fillet is not always included in these drawings.

This chapter does not include a Dates and Events section, since the symbolism in a Chinese carpet is much less affected by the time or place of manufacture than is true of the Middle East. Significant production of pile carpets only began after 1890 or so, when an export market developed.

Chinese Symbols

Artemisia Leaf

Dignity.

A Tang Dynasty revolutionary, Huang Chao, was laying waste to the countryside. Encountering a woman trying to shield her children, he placed some artemisia leaves over the door of her hut, commanding his men to spare dwellings with this sign.

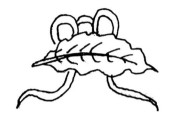

Bamboo

Symbol of long life and endurance: in a tempest, it bends but does not break. It also suggests good health, since it flourishes in winter.

Bamboo Tube and Magic Wand

A Taoist symbol for longevity.

Bat (fu)

Happiness (a homonym); long life. The bat is an attribute of Fu Hsing, a god of happiness.

The frequent combination of a bat and swastika forms the rebus *wan fu*: 'May you (or we) enjoy ten thousand kinds of happiness.'

Four bats with the sign for happiness suggest four happinesses.

Five bats suggest five blessings: health, wealth, virtue (or children), long life, a tranquil end.

A bat together with a revolving stone indicates happiness and blessings and, with a peach, happiness and longevity.

Book

Learning: the basic attribute of a scholar. One Chinese encyclopaedia ran to 10,000 volumes, with four times the content of the *Encyclopaedia Britannica*.

Butterfly

Joy, summer, conjugal bliss.

It also, however, suggests old age.

Canopy

One of the signs found on the sole of Buddha's foot, signifying protection.

Castanets or Clappers

The emblem of Tsao Kuo-Chin, one of the Eight Taoist Immortals, and patron saint of the theatre.

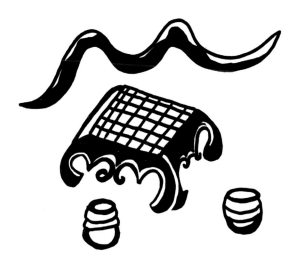

Chessboard

One of the pleasures of the literati.

Chou or Shou

A symbol of fortunate longevity. It occurs in many variations, and migrated to the Middle East.

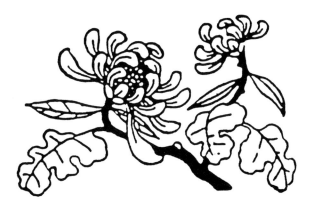

Chrysanthemum

Autumn, and thus pleasant retirement and long life.

Cloud Band or Chi

A very widely used Chinese motif, perhaps of Mongol or earlier origin. It appears in Middle Eastern carpets in the late Timurid period, towards the end of the fifteenth century, brought by the Mongol invasions. It suggests immortality, and is associated with the sacred *ling-chi* or 'cloud' or purple fungus, *polyporus lucidus*, which is considered to suggest the female genitalia, or *Yin*; the *mons veneris* was called the 'peak of the purple fungus'.

It grows at the base of trees and when dried is very long-lasting—which may be the basis of its association with longevity and, for Taoists, who hoped for eternal life, with immortality.

Lao Tse is sometimes depicted with this fungus, which is also shown in the mouths of deer.

While the fungus is soft, grass can grow through it, represented in art by grass-like leaves, also called the grass of the immortal soul.

An additional possibility could be the fly agaric mushroom, *ling wan chou* or *amanita muscaria* (which may be the *soma* of the vedas).[22] It grows at the base of trees, notably the Russian birch, and is noted for its intoxicating effect on deer, whose urine, when they have eaten it, is hallucinogenic to humans.

Some writers, including Robert Graves, associate the *amanita muscaria* with the origins of several Mediterranean mystery cults.

[22] An idea suggested by the author to R. Gordon Wasson, who would certainly have discovered it anyway, and who developed it in *Soma, Divine Mushroom of Immortality*. New York: Harcourt, Brace & World, Inc., 1968.

Cloud Collar—Yun Chien
The outward-reaching points probably symbolize radiating energy, much as we suggest the sun today as an orb with streaks pointing outward.

Cloud Pattern

A favourite decorative motif, which occurs in a number of variations, including the *ruyi*, a symmetrical outline, and the solid, tailed 'drifting cloud'.

In the Chinese philosophic tradition it suggests the self-extinction to which a sage must submit in order to attain to a higher level of existence.

(Conch) Shell

Symbolizes the voice of Buddha, and is thus blown as a call to prayer. It is also an emblem of royalty, and a talisman of a safe sea voyage.

Crane

A beloved bird, sent by Shou Hsing, the Taoist god of longevity, to lead the dead to the next world. It was the Manchu symbol of top official rank.

In mythology it lives thousands of years and so signifies long life and success. According to fable, it can subsist on fluids after 600 years of life, and turns black after 2,000 years.

Every four millennia, on a high mountain summit, the fungus of immortality appears, and lasts one day. The crane carries a deer, representing mankind, to the mountaintop of divine power to partake of the fungus.

A crane flying over a deer combines three concepts: longevity for the crane, and happiness plus official emoluments (*lu*) for the deer.

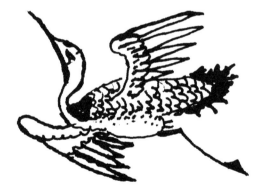

Dragon (*lung,* if five claws; *mang* if four; *kuilung* for a stylized archaic design)

The principal Chinese symbol from early times has been the dragon: one of the Four Supernatural Creatures, powerful but benevolent. It represents the deity and, after the third century AD, the Emperor. For Taoists it suggests the Tao or Way—the universal force, and in Zen, enlightenment.

It has an exaggerated camel's head with the horns of a stag, and possesses a wingless serpentine body, with four legs, a tiger's paws and a falcon's claws. From the fourteenth century on, in the Ming and Ching periods, only textiles made for the Imperial family could depict a five-clawed dragon; lesser dignitaries were confined to four or three claws. After the abolition of the Chinese Empire in 1912 this restriction lapsed, so five claws became usual.

A flaming ball or pearl near the dragon's mouth indicates thunder.

Cloud symbols are usually found nearby.

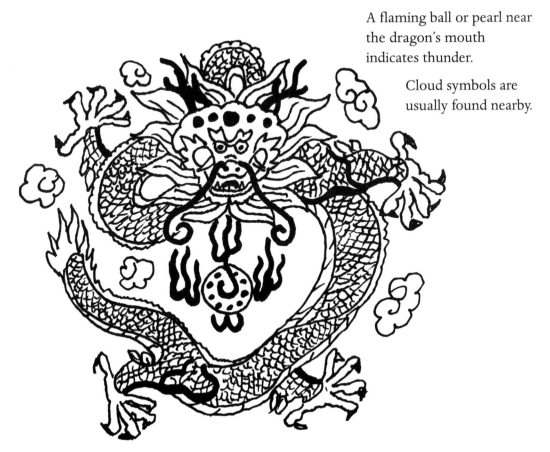

Fan

Often carried by retired scholars and persons of rank. Since a fan is laid aside in cool weather, an abandoned wife is called an 'autumn fan'.

It is the emblem of the magician Chung-Li Chuan, one of the eight Taoist Immortals; with it he could revive the souls of the dead. While out walking he once came upon a young woman fanning a grave. When Chung-Li questioned her, it emerged that her husband had exhorted her not to remarry until the earth on his grave was dry. But she had found a lover, and so she was fanning busily away to expedite matters. Chung-Li helped the process along, using his magical powers. The grave having dried, the young woman cheerfully waltzed off, abandoning her fan. Chung-Li kept it.

Fish

One of the signs on the sole of Buddha's foot. It implies liberation and struggling against difficulties, from the arduous swim upriver to spawning-grounds.

The word suggests abundance, wealth and love, all homonyms (*yu*). A pair of fish, usually carp, signifies happy marriage or friendship. One carp signifies wealth and / or a prominent position.[23]

23 In Japan they are favoured by the newly rich, not infrequently politicians, and so are in some disrepute. I proposed to one concerned magnate that he place a sign by his tank saying 'Old Rich'. This move may be under consideration.

Flower Basket

The emblem of Lan Tsai-Ho, one of the Eight Taoist Immortals, and patroness of florists. The ephemeral pleasures of our brief lives are, she maintained, but an illusion.

Flute

This ancient instrument is the emblem of Han Hsiang-Tsu, one of the Eight Taoist Immortals. Like Orpheus, he attracted birds and animals with his music.

Three Fruits

Peach, pomegranate and the 'hand of Buddha' fruit (*fo shou* or *citrus medica*): long life, children, fortune and honour.

The *fo shou* is considered to suggest Buddha's hand with the index and little fingers elevated; also wealth, since it looks like a hand taking money.

Gourd and Crutch

A pilgrim's gourd, used as a bottle, is the emblem of Li Tieh-Kuai, one of the Eight Taoist Immortals. He is always shown with a crutch, since once, travelling out of his body in the spirit world, he returned to find his body burnt. Seeking a substitute body, he entered that of a recently dead lame beggar, and so thereafter required a crutch.

Horse

Nobility, strength.

Like the tank today, horses were very important to the Chinese in times past, particularly war-horses, which were central to military power. The Chinese possessed horse-drawn chariots—and, indeed, powerful crossbows with bronze fittings—many centuries BC.

The large—15 to 16 hands—and powerful Turkoman or *Turki* horses were more useful than the small, shaggy native Chinese ponies, so the Chinese paid higher and higher prices for them, eventually reaching as much as 40 bales of silk for one animal.

Eight horses together suggest the mythical kingdom of Mu, while one with wings suggests the legendary 'dragon-horse'.

Ju-i (or joo-i or ruyi) Wand or Sceptre

A short sword that evolved into a wand, with a head bearing a cloud-symbol and a curved handle.

In both Taoism and Buddhism, it suggested longevity, literary success and the satisfaction of wishes. Literati liked to leave them about on display as decorative objects, and to give them as presents.

Key and Fret Border

A variation of *Swastika*.

Knot (chang)

The endless knot of destiny resembles our symbol for infinity in mathematics. One of the signs on Buddha's foot, it also represents his intestines, and thus compassion, like the Biblical 'bowels of compassion'. Being without end, it signifies longevity. It suggests Buddha's admonition against taking life, stealing, lewdness, bearing false witness and drinking alcohol.

Lion or Dog of Fo

He has a large, alarming head with a huge mouth, and is often shown playing with a ball or *chu*. Although not considered particularly fierce, like a tiger, the Chinese symbolic lion is brave and strong. The same symbol may represent the Dog of Fo, which guards Buddhist temples.

Lotus

An extremely ancient and universal symbol, occurring as early as 3000 BC in Mohenjo-Daro.

For Buddhists, the lotus is a sacred flower, whose petals represent the cycles of existence. In art, Buddha, called 'the jewel in the lotus', is frequently shown enthroned on a lotus blossom. It signifies purity, summer and spiritual perfection, since it grows in mud without being defiled. It is the symbol of Kwan-Yin, queen of heaven and goddess of compassion, and of Ho Hsien-Ku, one of the Eight Taoist Immortals, who subsisted on moonbeams and powdered mother-of-pearl. The Hindu god Vishnu's wife, Lakshmi, issued from a lotus on his forehead, and Brahma from his 'lotus-navel'.

Lute or Harp

Conjugal happiness, friendship, purity, and moderation in official life. One of the attributes of a scholar.

Mountain (shoushan fuhai)

In Buddhism, this symbolizes detachment from the material, and the search for salvation.

It indicates the centre of the universe, rising from the ocean of eternity.

Narcissus or Daffodil

Suggests winter, since it blooms in that season.

Orchid

Symbolizes beauty, moderation and refinement.

Paintings

Actually, two scrolls. One of the pleasures of the literati; it includes calligraphy. Chinese painting is a voiceless poem which transmits an idea, rather than passively depicting nature. It is essentially suggestive: the solitary sage gazing at the mist in a Chinese landscape painting is also contemplating human existence.

Parasol or Umbrella

For Buddhists, dignity, esteem.

The 'parasol of state' signifies high governmental rank or dignity. It is one of the signs on Buddha's foot, and is taken to represent his spleen, an emotional centre.

Peach

The fruit is a symbol of spring, marriage (from a homonym) and longevity. It appears frequently with a bat, signifying a long, happy life. The god of longevity is depicted emerging from a peach.

Peach, lotus, chrysanthemum and narcissus together signify the four seasons.

The Western Paradise has a peach tree at its centre. Legend has it that a monk seeking to marry a fairy sought to steal a peach from this tree so that he too could become immortal. But with the fruit in his very grasp he was transformed into a monkey. So the expression 'monkey with peach' warns against spiritual shortcuts or seeking too high a position.

The *blossom* of the peach is short-lived, and thus belies the longevity implied by the fruit. A fallen blossom implies a prostitute.

Pearl

One of the Eight Ordinary Symbols. It represents beauty and truth and, entwined with a fillet, good luck. A child born to an elderly couple is called a pearl from an old oyster.

See also *Dragon*.

Peony

The *Yang* flower, signifying masculinity, wealth and reputation; also however, love, a beloved woman, spring and high spirits. A peony together with a chrysanthemum symbolizes a life of ease and retirement from office, and with a peach, a long, prosperous, well-reputed life.

This beloved flower occupies much the same position for the Chinese as the rose for westerners.

Pheasant

Symbol of a Ming scholar. Employed as insignia by both second- and fifth-rank officials, it symbolizes five virtues: its comb, or *wen*, indicates literary talent; its spurs or *wu*, martial valour; its supposed readiness to share food, *jen*, goodwill; its combativeness, *yung*, courage; its reliability, as in signalling daybreak, *hsin,* trustworthiness.

Phoenix (feng-huang)

The benevolent chief of birds: a mixture of stork, peacock and pheasant, among other combinations. The embodiment of *Yang,* it is the emblem of the Empress, and does not resemble the phoenix of western tradition. The five colours of its feathers symbolize the five cardinal virtues and five elements. It usually appears together with a dragon, (a *Yin* emblem), and is associated with good news, happiness, peace and the warmth of the sun.

Technically, *feng* is a male phoenix and *huang* a female.

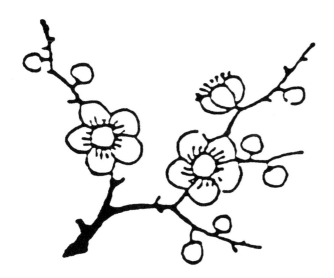

Plum blossom

Winter, rectitude, beauty and longevity, since it blossoms when very old. Lao Tse, founder of Taoism, was said to have been born under a plum tree. Tsao Chih (AD 192–232) advises against attracting suspicion by pulling up one's boots in a field of melons or straightening one's hat under a plum tree, for fear of being suspected of stealing melons or plums.

Pomegranate

A symbol of fertility and abundance in many cultures. For the Chinese, it expresses a wish for many (virtuous and male) children.

Stag (lu) or Deer

Longevity and wealth.

For Taoists, well-being and official emoluments. Stag-hunting was an aristocratic pursuit, as in Europe. Generally spotted, as it in fact is in China, it may be shown eating a *ling-chi* fungus. The hallucinogenic *amanita muscaria*—which the *ling-chi* could symbolize—has a 'second state', still hallucinogenic, namely the urine of the deer that have eaten it, which formed the basis of a shamanistic cult.

See also *Cloud Band*.

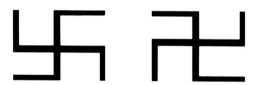

Swastika (wan)

One of the oldest and most universal symbols, perhaps originally a sun sign; an ancient symbol for thunder. It is one of the 'auspicious signs' on Buddha's foot. It represents ten thousand (whence a desire for long life) and the heart and mind of Buddha. Enclosed in a square, it signifies fertility; placed together with a *chi*, happiness, eternity and fame. The clockwise version, or *gammadion,* is generally *Yang*, solar and masculine, and the counter-clockwise version, *Yin*, lunar and feminine.

Our word may derive from Sanskrit: *su* — 'well'—, plus *asti* —'it is'.

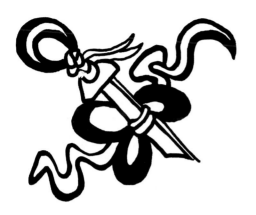

Sword

In Taoist symbolism, the triumph of good over evil. It is the emblem of Lu Tung Sin, one of the Eight Immortals. Armed with his resistless sword, he roamed about like a knight-errant, skewering dragons and other malefactors. As a Buddhist symbol, the sword symbolizes wisdom cutting away the undergrowth of error to reveal truth.

Thunder

Originally this was an ancient hieroglyphic, in roughly spiral form. When it became a formal ideogram, it assumed an angular character, often combined in pairs, which in turn developed into a broader design.

Placed before a dragon, a ball or pearl may symbolize thunder.

Trigrams

An ancient fortune-telling device, extremely influential in Chinese philosophy; highly regarded, incidentally, by Jung.[24] Tradition has it that they were created by the emperor Fu-Hsi in the third millennium BC.

The long continuous lines are *Yang:* male, active, warm, creative, and suggesting the sun and the south, while the short interrupted lines are *Yin:* female, cool, receptive, and suggesting the moon and the north. Thus, three long lines or *chien,* the Creative, are totally *Yang,* suggesting the sky, summer and father, while three interrupted pairs of short ones or *kun,* the Receptive, are totally *Yin,* suggesting earth, winter and mother. Two interrupted lines above a continuous one or *chen,* the Arousing, suggests spring and thunder; and so on.

[24] See his long Foreword to *The I Ching or Book of Changes,* trans. Richard Wilhelm and Cary F. Baynes. Princeton: Princeton University Press, 1977.

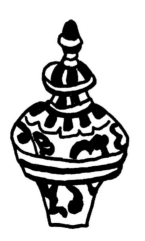

Vase or Urn

One of the symbols on Buddha's foot. 'Vase', *ping,* is a homonym for 'peace', 'table', *an,* for 'tranquillity', and the *Ju-i* stick for 'fulfilling a wish'. So a vase and *Ju-i* stick on a table mean 'may we find the tranquil peace we wish'.

Water (shui-wen)

A series of figures resembling partly superimposed semicircles. If the semicircular figures are smooth, they represent still water; if angular, then ocean waves. Usually occurs with a *Mountain*.

Wheel of the Law

One of the sacred signs on Buddha's foot. Also called the wheel of *dharma*, life or truth. The tradition is that Buddha drew it for his disciples in a rice field with grains of rice. The spokes of the wheel represent his rules of conduct.

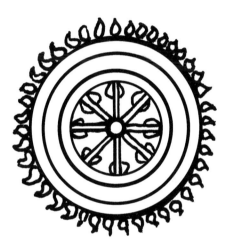

Yin-Yang

See *Trigrams*.

Other Chinese Symbols
and Some of Their Meanings

Birds:
Happy marriage.

Buffalo:
Endurance.

Cock and Hen:
Country life.

Coin:
Prosperity.

Crow:
Evil.

Globe:
Domination.

Goose:
Domestic happiness.

Ling-chi:
See Cloud Band.

Oblique Lines:
Waves; troubles.

Octopus:
Firmness.

Old man with staff:
Long life.

Owl:
Dread.

Peacock feather:
On a hat, indicates imperial rank.

Poppy:
Influence, wealth.

Rose and Anemone:
Patience.

Tiger:
Courage.

Tortoise:
Long life.

Tree of Life with Seven Branches:
The seven days of the creation of the world.

Unicorn (kylin or chi-lin): The body of a deer and the head of a dragon, with flaming shoulders, a horse's hoofs and the tail of an ox: announces the birth of a sage, e.g., Confucius; nobility, gentleness, religious integrity.

Weeping Willow: Native to China; to Buddhists its swaying in the wind suggests meekness.

Bibliography

The most penetrating studies on rug symbols are monographs on particular themes. A few are among the works cited below. They are most readily available in specialized libraries, such as the Textile Museum in Washington. Recent books are likely to be more reliable than those published before 1970, say, when the explanations were more conjectural.

Akşit, Zürüt. *Turkish Carpet Art*. Istanbul: Akşit Kültür Turism Sanat Anans Ltd. Şti., 1995.

Allane, Lee. *Oriental Rugs, a Buyer's Guide*. London: Thames and Hudson, 1988.

Ateş, Mehmet. *Turkish Carpets, the Language of Motifs and Symbols*. Antalya, Turkey: 1995.

Azadi, Siawosch, trans. Robert Pinner. *Turkoman Carpets and the Ethnographic Significance of their Ornaments*. Fishguard, Wales: The Crosby Press, 1975.

Beattie, May H. *The Thyssen-Bornemisza Collection of Oriental Rugs*. Castagnola, Italy: Villa Favorita, 1972.

Bennett, Ian. *Oriental Rugs, Vol. 1: Caucasian*. Woodbridge, England: Oriental Textiles Press, 1981.

Berinstain, Valerie, et al. *Great Carpets of the World*. New York: The Vendome Press, 1996.

Bidder, Hans. *Carpets from Eastern Turkestan, Known as Khotan, Samarkand and Kansu Carpets*. New York: Universe Books, 1964.

Black, David, and Clive Loveless. *Rugs of the Wandering Baluch*. London: David Black Oriental Carpets, 1976.

Blair, Sheila S. and Jonathan M. Bloom, editors. *Images of Paradise in Islamic Art*. Hanover, NH: Dartmouth College, 1991.

Bruggemann, W. and H. Bohmer. *Rugs of the Peasants and Nomads of Anatolia*. Munich: Kunst & Antiquitaten, 1983.

de Calatchi, Robert. *Oriental Carpets*. Rutland, VT and Tokyo: Charles E. Tuttle Co., 1967.

Chenciner, Robert. *Kaitag, L'Art Textile du Daghestan*. London: L'Institut du Monde Arabe and Textile Art Publications, Ltd., 1994.

Chevalier, Jean and Ghearbrant, Alain. *Dictionnaire des Symboles*. Paris: Laffont/Jupiter, 1982.

Cooper, J. C. *Symbolism, the Universal Language*. Wellingborough, Northamptonshire: The Aquarian Press, 1982.

Cootner, Cathryn. *The Arthur D. Jenkins Collection: vol. 1, Flatwoven Textiles*. Washington: Textile Museum, 1981

Davies, Peter. *The Tribal Eye: Antique Kilims of Anatolia*. New York: Rizzoli, 1993.

Dilley, Arthur U., revised by Maurice S. Dimand. *Oriental Rugs and Carpets*. Philadelphia and New York: J. B. Lippincott Co., 1959.

Dimand, Maurice, and Jean Mailey. *Oriental Rugs in the Metropolitan Museum of Art*. New York: Metropolitan Museum of Art, 1973.

Eagleton, William. *An Introduction to Kurdish Rugs and Other Weavings*. New York: Interlink Books, 1988.

Edwards, A. Cecil. *The Persian Carpet*. London: Duckworth Ltd., 1975.

Eiland, Murray. *Oriental Rugs, a Comprehensive Guide*. Boston: Little Brown and Co., 1981.

Eiland, Murray. *Chinese and Exotic Rugs*. Boston: New York Graphic Society, 1979.

Ellis, Charles Grant. *Early Caucasian Rugs*. Washington: Textile Museum, 1976.

Ellis, Charles Grant. *Oriental Carpets in the Philadelphia Museum of Art*. Philadelphia: Philadelphia Museum of Art, 1988.

Erbek, Güran. *Kilim, Catalogue No. 1*. Istanbul: Selçuk A.Ş., 1990.

Ettinghausen, Richard, Maurice S. Dimand and Louise Mackie. *Prayer Rugs*. Washington: Textile Museum, 1974.

Ford, P. R. J. *Oriental Carpet Design: A Guide to Traditional Motifs, Patterns and Symbols*. London: Thames and Hudson, Ltd., 1981 and 1989.

Gregorian, Arthur T. *Oriental Rugs and the Stories They Tell*. Boston: The Nimrod Press, 1967.

Guppy, Shusha. *The Blindfold Horse*. London: William Heinemann Ltd., 1988.

Hackmack, Adolf. *Chinese Carpets and Rugs*. Tientsin: La Librarie Française, 1924.

Hall, James. *Illustrated Dictionary of Symbols in Eastern and Western Art*. New York: HarperCollins Publishers, 1994.

Hawley, Walter A. *Oriental Rugs Antique and Modern*. New York: Dover Publications, 1970.

Hubel, Reinhard B. *The Book of Carpets*. New York: Praeger Publishers, 1970.

Jerrehian, Aram. *Oriental Rug Primer*. New York: Running Press, 1980.

Kybalová, Ludmila and Dominique Darbois. *Carpets of the Orient*. London: Paul Hamlyn, 1969.

Loges, Werner. *Turkoman Tribal Rugs*. Translated by Raoul Tschebull. Atlantic Highlands, NJ: Humanities Press, 1980.

Lorentz, H. A. *A View of Chinese Rugs from the 17th Century to the 20th Century*. London and Boston: Routledge and Kegan Paul, 1972.

Mackie, Louise and Jon Thompson. *Turkmen, Tribal Carpets and Traditions*. Washington: Textile Museum, 1980.

Middleton, Andrew. *Rugs & Carpets: Techniques, Traditions & Designs*. London: Mitchell Beazley, an imprint of Reed Books, 1996.

Opie, James. *Tribal Rugs*. London: Laurence King Publishing, 1992.

Opie, James. *Tribal Rugs of Southern Persia*. Portland, OR: James Opie Oriental Rugs, 1981.

Orientteppiche. München: Battenberg Verlag.

 Band 1: Doris Eder, *Kaukasische Teppiche*, 1988

 Band 2: Erich Aschenbrenner, *Persische Teppiche*, 1988.

 Band 3: Kurt Zipper & Claudia Fritzsche, *Anatolische Teppiche*, 1989.

 Band 4: Uwe Jourdan, *Turkmenische Teppiche*, 1989.

 Band 5: Taher Sabahi, *Kelims—Kaukasische Flachgewebe*, 1992.

Paine, Sheila. *The Afghan Amulet*. New York: St. Martin's Press, 1994.

Peasant and Nomad Rugs of Asia. Asia House Gallery, 1961.

Pinner, Robert and Michael Franses, editors. *Turkoman Studies I*. London: Oguz Press, 1980.

Pinner, Robert and Walter B. Denny, editors. *Oriental Carpet and Textile Studies, vol. 3, no. 2*. London: Islamic Department of Sotheby's and OCTS Ltd., 1995.

Purdon, Nicholas. *Carpet and Textile Patterns*. London: Laurence King Publishing, 1996.

Reed, Stanley. *Oriental Rugs and Carpets, Pleasures and Treasures*. New York: G. P. Putnam's Sons, 1967.

Руденко С. И. (Rudenko, S. I.) Древнейшие В Мире Художественные Ковры и Тканил: из оледенелых курганов Горного алтая. Москва: Издателъство „Искусство," 1968. (On the Pazyryk Carpet; has English summaries.)

Schlamminger, Karl, and P. L. Wilson. *Persische Bildteppiche*. Munich: Callwey Verlag, 1980.

Schurmann, Ulrich. *Caucasian Rugs*. London: George Allen & Unwin, Ltd., 1965.

Schafer, Edward H. *The Golden Peaches of Samarkand, a Study of T'ang Exotics*. Berkeley: University of California Press, 1963/1985.

Spuhler, F., M. Volkmann and H. Konig. *Alte Orientteppiche*. Munich: Verlag Callwey, 1978.

Spuhler, Friedrich. *Oriental Carpets in the Museum of Islamic Art, Berlin*. Washington: Smithsonian Institution, 1987.

Sze, Mai-Mai. *The Tao of Painting: A Study of the Ritual Disposition of Chinese Painting, vol. I*. New York: Pantheon Books, Bollingen Series XLIX, 1956.

Tanavoli, Parviz. *Shahsavan, Iranian Rugs and Textiles*. New York: Rizzoli, 1985.

Thompson, Jon. *Oriental Carpets from the Tents, Cottages and Workshops of Asia*. New York: Dutton Studio Books, Penguin Books USA, Inc., 1983

Varvelli, M. L. *I Tappetti*. Firenze: G. C. Sansoni S.p.A., 1969.

Williams, C. A. S. *Outlines of Chinese Symbolism and Art Motives, 3rd rev. ed.* New York: Dover Publications Inc., 1976.

Articles and Periodicals

The Çintamani Design in Turkish Carpets, *Hali* 64, August 1992.

Bierman, Irene. The Significance of Arabic Script on Carpets. Third International Conference on Oriental Carpets, *Hali*, vol. 5, no. 1, 1982.

Boston Museum Bulletin, vol. LXIX, nos. 355 and 356, 1971.

Cammann, Schuyler V. R. Symbolic Meanings in Oriental Rug Patterns. *The Textile Museum Journal*, vol. 3, no. 3, Parts I, II, III, 1972.

Cammann, Schuyler V. R. Cosmic Symbolism on Carpets from the Sangusko Group. *Studies in Art and Literature of the Near East*. New York, 1974.

Ramsey, Paul. The Dragon Dums of Daghestan. *Hali* 89, December 1996.

Index

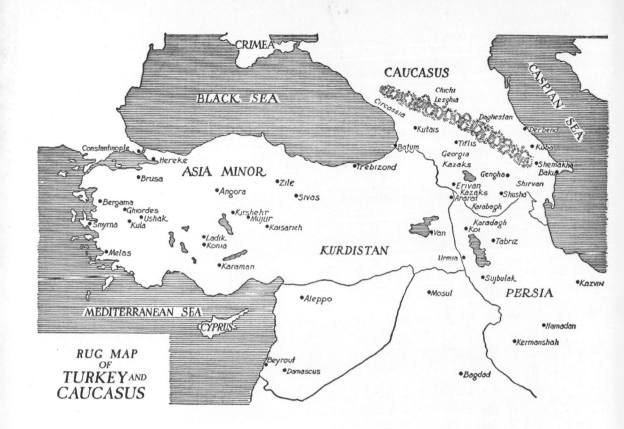

CRIMEA

CAUCASUS

BLACK SEA

Chichi
Leschia

Circassia

Daghestan

Kutais

Tiflis

Derbend

Kuba

Batum

Constantinople
Hereke

ASIA MINOR

Trebizond

Brusa

Zile

Angora

Sivas

Georgia
Kazaks

Gengha

Shemakha
Baku

Erivan
Kazaks
Ararat

Shirvan

Shusha

Bergama
Ghiordes
Ushak

Kirshehr
Mujur
Kaisarieh

Karabagh

Karadagh
Koi

Tabriz

CASPIAN SEA

Smyrna
Kula

Ladik
Konia

Van

Urmia

Melas

Karaman

KURDISTAN

Sujbulak

PERSIA

Kazvin

MEDITERRANEAN SEA

CYPRUS

Aleppo

Mosul

Hamadan

Kermanshah

RUG MAP
OF
TURKEY AND
CAUCASUS

Beyrout
Damascus

Bagdad

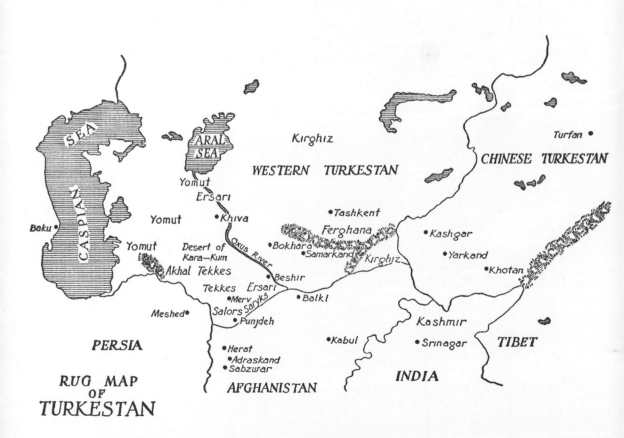

SEA

ARAL
SEA

Kirghiz

WESTERN TURKESTAN

Turfan

CHINESE TURKESTAN

Yomut
Ersari

Yomut

Khiva

Tashkent

Ferghana

Kashgar

Baku

CASPIAN

Yomut

Desert of
Kara~Kum

Oxus River

Bokhara
Samarkand

Kirghiz

Yarkand

Khotan

Akhal Tekkes

Beshir

Tekkes *Ersari*

Merv
Salors *Saryks*

Balkl

Meshed

Punjdeh

Kashmir

Kabul

Srinagar

TIBET

PERSIA

Herat
Adraskand
Sabzwar

INDIA

RUG MAP
OF
TURKESTAN

AFGHANISTAN